Art & Illustration Techniques

by Harry Borgman

First Paperback Edition, 1988
Copyright ©1979, 1988 in New York by Watson-Guptill Publications

First published in 1979 in New York by Watson-Guptill Publications,
a division of Billboard Publications, Inc.,
1515 Broadway, New York, N.Y. 10036

Library of Congress Cataloging in Publication Data
Borgman, Harry.
 Art and illustration techniques.

 Includes index.
 1. Art—Technique. 2. Graphic arts—Technique.
I. Title.
N7430.B55 741.6 79-16228
ISBN 0-8230-0272-1
ISBN 0-8230-0271-3 (pbk.)

Manufactured in U.S.A.

1 2 3 4 5/92 91 90 89 88

WATSON-GUPTILL PUBLICATIONS, NEW YORK

To my teacher and good friend,
Sarkis Sarkisian

Contents

Introduction

This book is not a basic drawing book, but rather, one that deals with the subject of drawing and painting techniques. It is written for you, a potential painter or illustrator, and also for the developing artist who is eager to learn more about painting. You should be fairly proficient in basic drawing to really get the most out of this book. Actually, before attempting to do any painting, it is best to first develop your drawing skills, at least to the point where drawing is not a problem. This way, you will be able to concentrate more fully on painting, which, as you may have guessed, has unique problems of its own. I have written this book with the idea that you, the reader, are already progressing in basic drawing, but have little or no knowledge about the many techniques used in drawing or painting. I also assume that you are not aware of the drawing or painting mediums that can be used.

Through various demonstrations, I will show you professional techniques using these mediums: pencil, ink line, wash, markers, watercolor, designers colors, gouache, acrylic, and even mixed media. Within the space limitations of this book, I can only present a certain amount of material, so, in each category I have attempted to show you as wide a range of work as possible. For instance, in the acrylic section I include demonstrations painted in these styles: impressionistic, non-objective, realistic, and traditional. In presenting as much variety as possible, I hopefully will give you a thorough knowledge of how the various materials handle as well as what can be done with them. What I am attempting to do is to give you a good foundation—one that will encourage your growth as an artist.

The demonstration subject matter varies a great deal, ranging from figure studies to scenes, and abstractions to advertising illustrations. I have included paintings that have been done from life and others done using photographs for reference, while others are the product of my imagination. Certain demonstrations, such as still lifes or advertising illustrations, may not appeal to you. Still, you can learn much from

them and can apply your knowledge to other areas of painting. So, do not close your mind because something doesn't quite catch your fancy.

It is also possible that you may just not be interested in working in many different ways or in all the mediums shown. However, the book will offer you information that might help you make a better choice of the type of medium you'll feel most comfortable with. Actually, most artists do not work in many different styles, preferring to work in one specific technique and medium. I personally enjoy working in a variety of techniques. This probably developed from the fact that in my business of advertising art, I am frequently called upon to work in many different styles, and am often asked to develop new techniques, which I find most interesting. This background has proven useful when teaching students, and it also has enabled me to write art instruction books, based on a variety of personal experiences. You may wonder if I have a personal preference in mediums. I love working with acrylic the most, and lately have been doing non-objective paintings. I also find watercolor challenging and exciting, and use it a great deal.

Of course, I enjoy my profession of illustration, but the rigors of meeting tough deadlines can be quite wearing. This is a fact that should be given full consideration, if you are thinking of entering the commercial art field. In other words, do you feel you can work well under a lot of pressure?

What Is Illustration?
You may wonder just what the field of illustration encompasses and how it differs from painting. Illustration is just what the word implies: a picture, a drawing, or even a diagram that embellishes a book, article, or advertisement. Illustration can also be a form of painting, often executed with the same care and sensitivity. But most illustrations do have some sort of restriction or limitation, which is really the difference.

I have always found that many people, in-

cluding gallery owners and the advertising community, make a definite distinction between an illustrator and a painter. In Europe, though, this distinction does not seem to exist—there is no stigma attached to being an illustrator. Painting and illustration are very closely related and some artists do both equally well. Hans Erni, of Switzerland, is a perfect example of an artist who is equally at ease whether doing a poster, lithograph, painting, or an illustration—and he is a very good artist. Frederic Remington and Winslow Homer were probably America's best known illustrators and renowned painters as well. (Remington was also a sculptor.) James Montgomery Flagg, Howard Pyle, N. C. Wyeth, Frank Schoonover, and Maxfield Parrish were other illustrators who made important contributions to American art. Today, Andrew Wyeth is probably the country's most popular painter, and his work is very illustrative. Peter Max, a top-flight commercial artist, is now working in the fine art field. Some of today's best known illustrators such as Bernie Fuchs and Mark English also work in the fine art area.

The most significant ingredient of all, whether doing paintings or illustrations, is viewpoint. Viewpoint must be developed and cannot be taught, since it is really creativity. The greatest illustrators or painters are those who display the most creativity.

How to Use This Book
In each category discussed, you will find practice exercises as well as demonstrations. It is advisable that you do these exercises, since it is a good way to find out firsthand how different media work, and what can be done with them. Then, you should advance to doing small drawings or paintings. As you develop, you can move on to the more complex mediums and subject matter.

Follow the book through, starting with pencil, then ink, markers, and finally, paint. Watercolor and acrylic are more difficult to use, so when you start painting I would recommend that you begin with designers colors gouache.

Do not try to do too much at once. Do not work in markers, designers colors, and watercolor in the same period of development. This will only confuse you, and you will probably become quite discouraged. Stick with one medium until you have mastered it, or at least until you feel comfortable when using it. Remember to carefully study each step in the demonstrations as well as the color reproductions of the finished paintings. The additional examples presented in the color section should be scrutinized as well. As you develop and gain proficiency in each medium, you will actually see more in these examples than you did at first, so keep referring back to them. Also, start to study other artists' paintings and illustrations. As you can see, this is a growing process as well as a learning experience.

I would also suggest that you do not discard or destroy any of your efforts. Keep all of your drawings and paintings for future comparison. You will be amazed how you can improve when you really work at it. Do not be misled or discouraged by all the different methods and techniques presented in this book. They are shown to give you an idea of how diverse these mediums can be. Keep in mind that I did not learn these techniques overnight, but accomplished these skills over a long period of time. You would also be mistaken to feel that something is too tough to try. Do not be afraid to attempt any technique or medium. The best way to really learn is by making mistakes and starting over. On the other hand, do not take on a project that will be too much for you. For instance, do not begin to use acrylic by painting on a 5' × 6' (1.5 × 2 m) canvas. The rule should be: Build up to advanced projects gradually. All of your beginning efforts should be small drawings or paintings of *simple* subjects.

A great deal of information is presented in this book, so take it all in slowly. Reread all the step-by-step demonstrations as well as the practice suggestions, and try to apply them to your own work. An instruction book is one that should be used.

Part 1
Developing an Illustration

It is quite interesting to follow the many stages an advertising illustration goes through before reaching the final print. In this section of the book, I cover in step-by-step sequence an advertising illustration from concept to finished ad. This illustration was an assignment for a French advertising agency, M.A.O., Akjaly, Stollerman, and it will be a full-color magazine ad for Sogitec Industries, an interesting firm that specializes in producing training programs and in storing information and data.

The creative director, Ray Stollerman, had seen a brochure I produced for Texstar Corporation, and he felt that its design quality would work well for the Sogitec ad. We discussed what was wanted in the ad, and we decided I should work up two or three rough concept sketches, which could then be presented to the client. The results of this meeting would give us the direction for the final illustration.

A Case History

This particular assignment proved to be a rather difficult one with an unusual number of client changes. Because of this, however, it does make an interesting case study. Keep in mind that the many changes involved here are the exception rather than the rule.

Sogitec does work for a variety of clients including French aircraft companies, oil refineries, the national railroad, the French space program, and even the Louvre. To show the great diversification of their work, we decided to do a montage-type of illustration, which would allow us to show many elements.

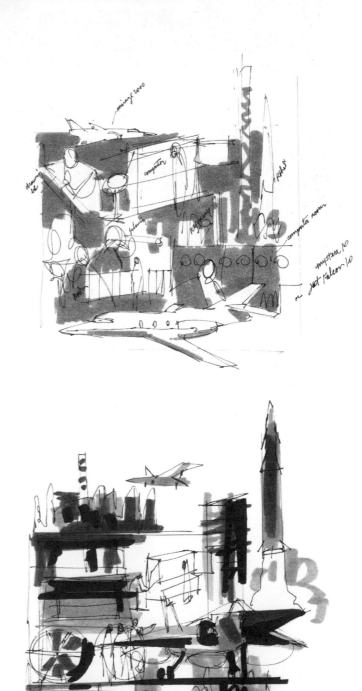

These spot illustrations were done for the Texstar Corporation brochure, which influenced the creative director in his decision to use me on the Sogitec ad. Even though these sketches are very roughly done, they still can be a great help when discussing an advertising concept with a client. The two examples on the right were presented to the client during our initial meeting.

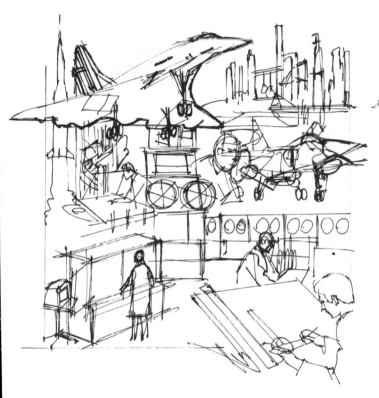

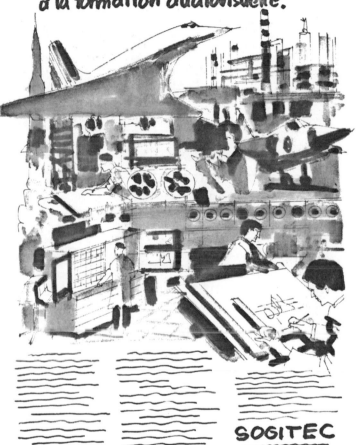

**Sogitec.
Du traitement de l'information industrielle
à la formation audiovisuelle.**

SOGITEC

This is the type of sketch I do as an underlay, when rendering my rough visuals in tone on layout paper. It can be drawn with a pencil or a fine marker pen.

On this rough visual, the creative director added the headline and a simulated copy block. The client was most interested in this sketch. Some changes were discussed and then incorporated into a new, tighter sketch.

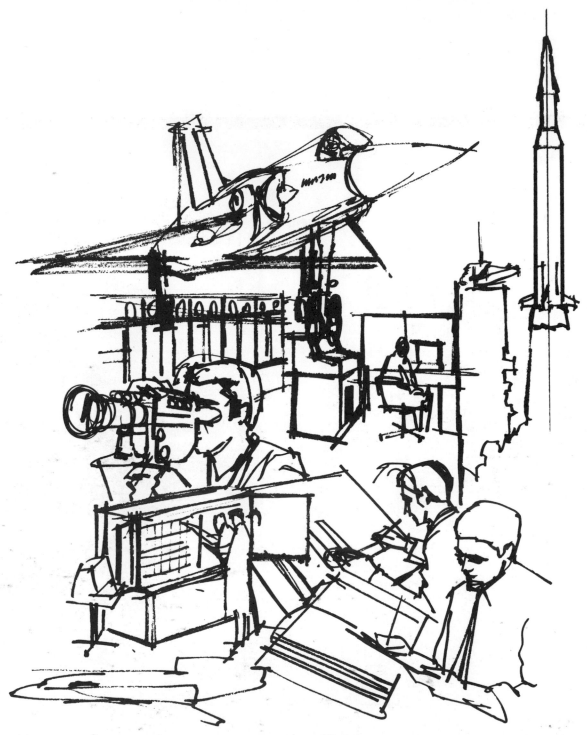

(Above)
The client decided that we should not show the Concorde, but replace it with the latest French jet fighter, the Mirage 2000. He also wanted to add the new Dassault Jet Falcon. I was asked to put less emphasis on the man at the drawing board and to add a man checking a catalog in the foreground. Since much of Sogitec's work is in the film training area, they suggested that I add a cameraman. This is the new underlay sketch, showing all the new additions, and it is drawn with a marker pen.

(Right)
Here is the new rough resubmitted to the client; it was done on layout paper with Magic Markers. You can see that it is much more detailed and is also rendered a little tighter than the previous group. The client was pleased with this rough and requested that I now do a color comprehensive layout–the same size I would eventually paint the illustration. I should note here that most finished artwork is done larger than the size of the printed piece. It is much easier to work on a larger scale, especially when fine details are involved.

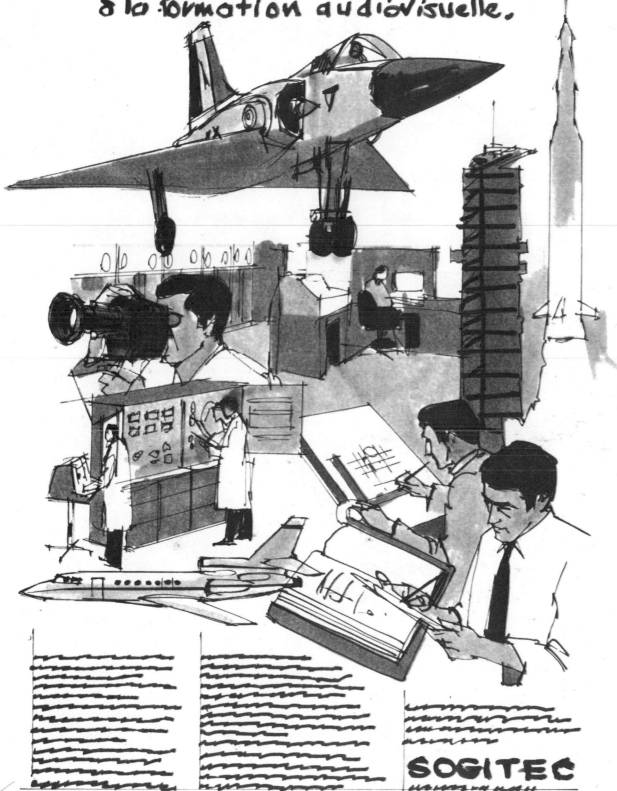

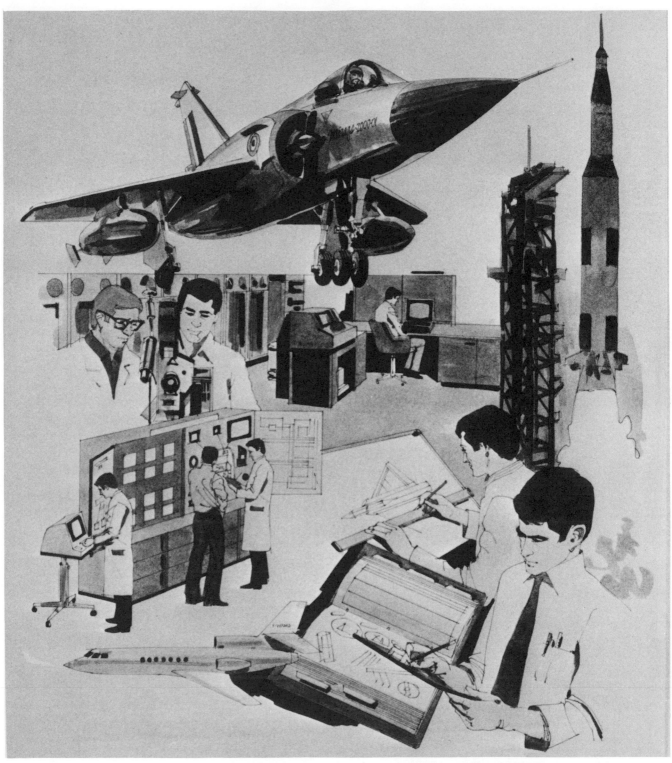

This color comprehensive layout was done the same size as the final art, 15" × 17½" (38 × 44.5 cm). It is rendered with Magic Markers on a high-quality layout paper. The thin lines were drawn with a Pilot Fineliner Ultra pen. This sketch was again presented to the client, hopefully for the final approval. Again, he wanted a few changes before going to finished art. It is better, of course, to work out all the problems on a job at this beginning stage, rather than when the illustration is finished. You can see the importance of presenting preliminary sketches.

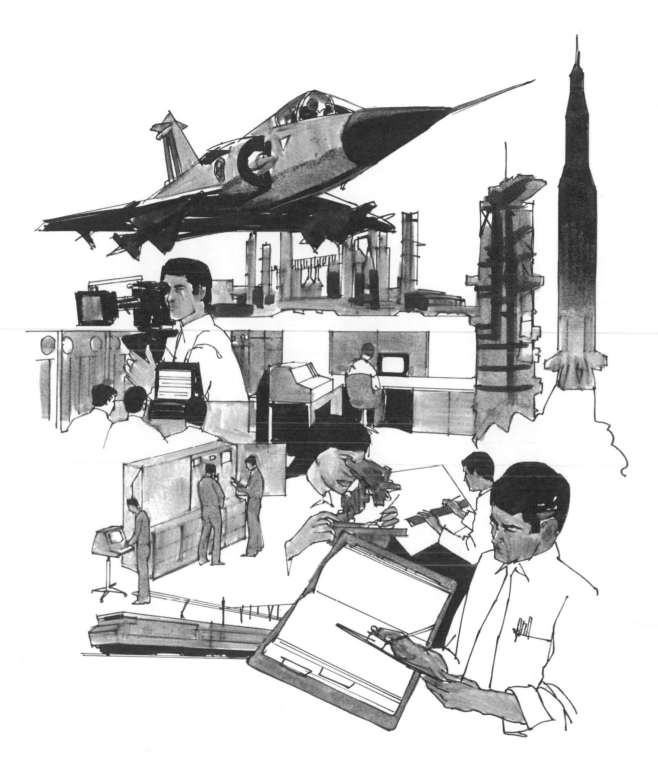

Here is the new sketch with the corrections and additions. This time it was done in black and white, since the previous sketch already showed the client how the color was to be handled. The new changes were to retract the landing gear and eliminate the wing tanks on the Mirage. Rockets were added under the wings. In addition, they felt that the cameramen were not defined, so I changed that also. Instead of the Falcon jet, they wanted a train in its place. An audiovisual table unit as well as an oil refinery were added. They also wanted a woman included somewhere in the ad, and suggested that I show a female technician assembling minute parts using a microscope. This sketch was accepted, but again with minor alterations.

This time I was not required to show another sketch, but I still had to do one for myself to help determine the new composition. The client wanted the train much larger and the audiovisual unit moved so that it could be seen better. Here is the final sketch that I used as a basis for my painting.

Before starting the finished art, however, I had to gather all the necessary reference material. An illustrator must have accurate reference material to work from, and often the client does not furnish you with adequate data or photographs. I had a difficult time finding any information on the Mirage jet fighter, since only two prototypes were built at the time and none of the aviation magazines carried much information on the aircraft. Finally, I did manage to acquire a photo of an artist's conception of the new plane, and I could see that it was very close to the previous models. I had plenty of material on the previous Mirages and was able to construct the new version without too much difficulty.

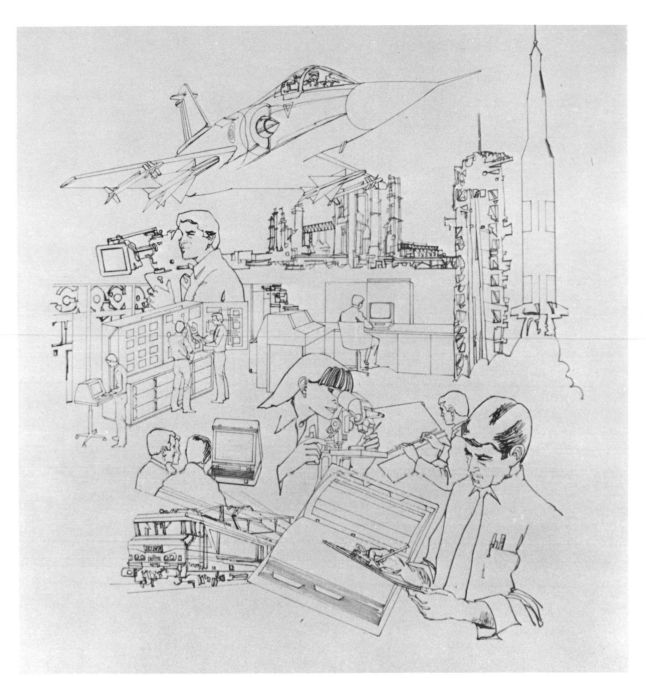

STEP 1. *I finally had the go-ahead to start the illustration. My deadline is one week, which is fairly good since an illustrator often will have only a couple of days to paint an ad. With all of my reference material in view, I start by doing a very accurate drawing with a 2H graphite pencil on tracing paper. When finished, I transfer the drawing to illustration board by using a graphite tracing sheet. Normally, I would have drawn most of the elements by actually projecting the reference photos onto the illustration board with a Beseler opaque projector. However, having recently moved to Paris, where the electrical current is 220 instead of 110, I was unable to utilize this method. I later installed a new motor in the projector so it would work properly on 220 current. Though not a necessity, a projector can be a real time-saving device when you find yourself under tight deadline pressures.*

After having completed the tracing of my tissue drawing, I carefully tighten up the tracing, finishing it up with a 2H graphite pencil. Since this illustration is to have a linear feeling, I start the rendering by inking over all the pencil lines. Rather than use a black for the lines, I feel a dark gray would look better, so I use India ink diluted with a little water.

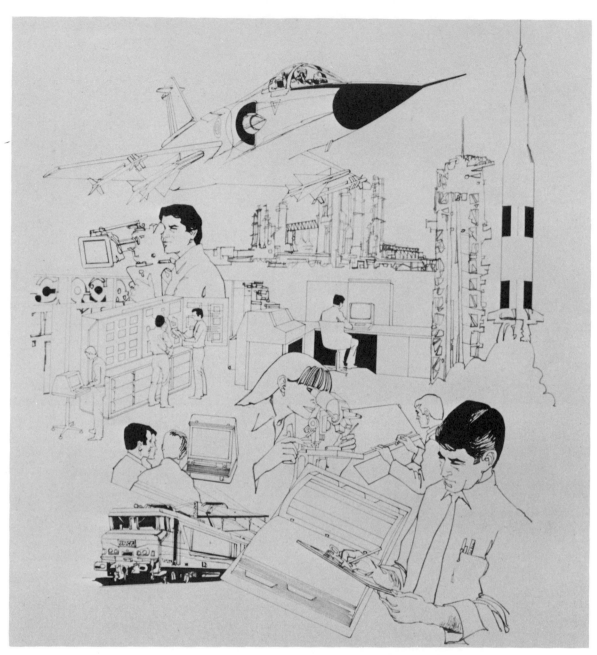

STEP 2. In order to determine my color values, I now add all the darkest areas throughout the illustration, using ivory black designers colors. All the darkest values are established first for a very good reason. If I had started working out my colors first, I would have tended to keep all the color values too light and would have had to change them later when the dark areas were added. The lightest value was established by the white board itself.

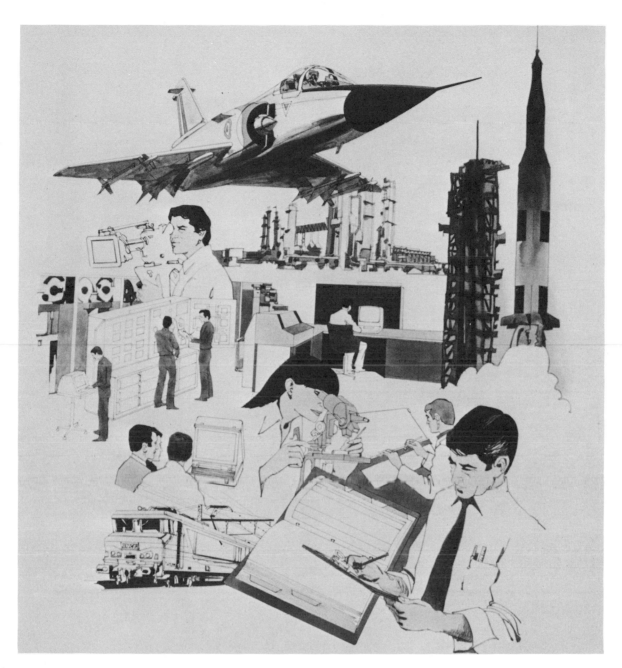

STEP 3. *This is essentially a line drawing that will be filled in with color. The creative director wanted the ad to have a fresh, bright feeling. Dyes and watercolor are the obvious choices, since this illustration will be rendered with clean, bright washes of color.*

I decide to paint the rocket launching segment first since it seems to be the most difficult part. In a sectioned ceramic tray, I put a few drops of Dr. Martin's dyes: cadmium yellow, persimmon, orange, and olive, adding a little Higgins water-soluble black ink for the darker tones. Using a large brush, I first dampen the board with clear water in the area to be painted. While the board is wet, I wash a little cadmium yellow behind the rocket, going over it with a wash of orange. Before

this is completely dry, I add a little olive green and some of the Higgins water-soluble black to darken the upper portion of the rocket. I wash a mixture of orange and persimmon over the rocket and the platform, letting this dry completely. Then I indicate the structural details of the rocket and platform with a wash of the water-soluble black ink.

Using Winsor & Newton watercolors, I wash a light value of manganese blue over the refinery and over the top part of the aircraft. I mix a little ivory black with the manganese blue and paint this on the underside of the wings and fuselage for the shadow tone. The bright reds and blues are added to the insignia, and a dark, neutral tone is painted over the cockpit section.

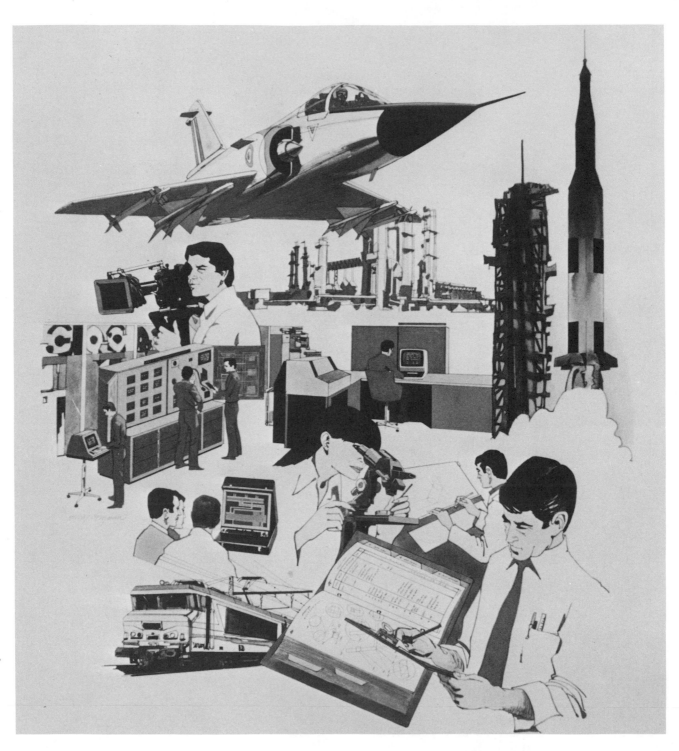

STEP 4. I continue working over the whole painting, but not finishing any one area. As I get everything filled in, I begin to have a pretty good idea of what the final illustration will look like. It is now becoming apparent that the color around the rocket is too bright and is overpowering the rest of the illustration. I tone this section down using opaque designers colors. A few more colors and values are changed throughout the picture and now I begin to finish everything in detail.

Opaque designer's colors are used to finish up the refinery and the Mirage jet aircraft. The train is completed in a very short time with a minimum of tones. The details of the computer are painted in. With a graphite 2H pencil, I carefully indicate a drawing on the draftsman's board. I also use the pencil to draw in the catalog pages in the lower foreground, thus completing the illustration. The rendering, not counting the preliminary work, took about 12 hours.

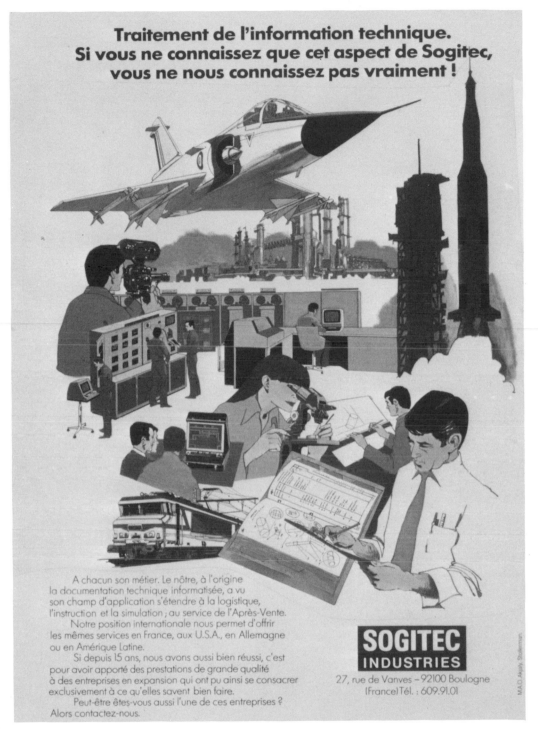

Traitement de l'information technique.
Si vous ne connaissez que cet aspect de Sogitec,
vous ne nous connaissez pas vraiment !

A chacun son métier. Le nôtre, à l'origine
la documentation technique informatisée, a vu
son champ d'application s'étendre à la logistique,
l'instruction et la simulation ; au service de l'Après-Vente.
Notre position internationale nous permet d'offrir
les mêmes services en France, aux U.S.A., en Allemagne
ou en Amérique Latine.
Si depuis 15 ans, nous avons aussi bien réussi, c'est
pour avoir apporté des prestations de grande qualité
à des entreprises en expansion qui ont pu ainsi se consacrer
exclusivement à ce qu'elles savent bien faire.
Peut-être êtes-vous aussi l'une de ces entreprises ?
Alors contactez-nous.

SOGITEC
INDUSTRIES
27, rue de Vanves – 92100 Boulogne
(France) Tél. : 609.91.01

STEP 5. *I submitted my finished illustration to the advertising agency, where it was well received. They, in turn, showed it to the client who decided that he did not like the figure of the cameraman facing toward the outside of the picture. I had to add a patch of illustration board and repaint the figure. The creative director also requested that I add a sky tone behind the refinery. I personally felt that none of these changes were necessary, nor did they add anything to the illustration.*

Part 2 Art Techniques

This part of the book covers eight basic categories containing 24 different demonstrations. The first categories include pencil, ink line, and ink tone, comprising nine demonstrations in black and white, while the 15 demonstrations that follow are all full-color. The full-color reproductions of the final steps are shown in Part 3, where you will also find additional examples of color work. Before you advance to working with color, stay within the framework of the first nine black-and-white demonstrations. This will give you preparation and the necessary groundwork to handle the more difficult mediums in the book. Pencil is a good place to start from, since everyone is already familiar with it. The first demonstration is an example of a simple graphite pencil line drawing with tones of gray, and this is followed by a more complex type of rendition with a charcoal pencil. The third demonstration is drawn with a different kind of pencil, a Stabilo All, which has a waxy kind of lead. You should concentrate your initial efforts on working with the different pencils, learning how they work on the various paper surfaces. Practice the exercise suggestions, then do your own drawings based on what I show in the demonstrations.

The second category is ink line. Demonstration 4 is a simple line drawing to which I add a tone, also made up of lines. The next, Demonstration 5, is an example of a brush ink drawing. At first, using the brush will be a little difficult, but practice will help you to develop the control that is necessary. This is important, since facility with a brush is a requirement of good rendering. Demonstration 6 appears quite complicated. It is a crosshatch line rendering done with a crowquill pen. If you study

this drawing carefully you will see that it is really quite simply done. Crosshatch drawings do, however, require more planning than some of the previous examples, so keep this in mind when doing them.

The third category again deals with ink, only this time ink washes. We are now entering the area of painting, which is a little more complicated than the previous mediums. Demonstration 7 is an ink line drawing with wash tones painted over, which is a simple approach for starting to work with ink washes. Demonstration 8 shows a good, fast sketch technique that will help limber you up in this medium and will also be useful for on-the-spot sketching, which is excellent practice. Demonstration 9 looks a lot more involved, though it is done using only two tones of gray and black ink.

Markers are the next logical category to introduce, especially since we will be dealing with color. My demonstration subjects are varied: a portrait, a mechanical device, and an outdoor scene. Markers are very easy to use, have pre-mixed colors, and dry rapidly. When starting to work in color, markers eliminate some of its difficulties, for instance, no mixing and no clean-up. Markers are actually a great way to learn about color. They are transparent, and when using one color over another you actually create new ones.

If you carefully observe the effects of certain colors over others, you will learn a lot about mixing colors. For instance, a red over a yellow will give you orange, a blue over the yellow will create green. This is why I suggest using markers before attempting any of the other painting mediums. You will probably

always use markers, since they are perfect for doing preliminary color sketches or studies for paintings in other mediums. If, at first, you feel unsure about working in color, you can start out by just using gray and black markers.

The next category is watercolor, which is a great medium and much more difficult than markers. Learning how to properly use watercolor is really an art in itself. It is well-suited for outdoor sketching, but if you are a little skeptical about painting outdoors, you can paint indoors, using Polaroid photos of your subject as reference. Demonstration 13 is a portrait of my wife, Jeanne. You might attempt a portrait, but it might be easier for you to begin with a still life, as I have painted in Demonstration 14. A still life won't move around or make you nervous, probably a much better choice for the beginner. Demonstration 15 illustrates the type of work I do when painting outdoors. This particular example was actually painted indoors, using a photograph as reference.

The sixth category is designers colors gouache, a paint that can be used either thin, like watercolor, or quite thick and opaque. Designers colors logically fit right after watercolors and before acrylics, but they are easier to use than both. Therefore, you should probably start painting with designers colors before trying watercolor and before going on to acrylic. Demonstration 16 is an illustration done primarily with washes of designers colors, which will help you greatly when you start working in watercolor. Demonstration 17 is an advertising assignment illustration. It is rendered with a combination of washes and opaque paint.

The seventh category, acrylic, includes four demonstrations. Demonstration 18 is a painting of Omaha Beach, Normandy, done in an impressionistic manner, followed by Demonstration 19, a non-objective painting—which I really enjoy doing. Demonstration 20 is an interesting advertising assignment, painted on canvas. The last one, Demonstration 21, is a figure study, done realistically in another technique. These four demonstrations do not cover the full range of what can be done with this medium. Consequently, in Part 3, the color section, you will find eight additional examples, all quite different, which will give you more of an idea of acrylic possibilities.

The last category concentrates on mixed mediums. Pencil can be used with inks, dyes, or acrylic paints, and you can even add designers colors and markers to this group. Just about anything you can think of will work. In Demonstration 22 I show how designers colors can be used with colored pencils effectively. In Demonstration 23, I have converted a black-and-white line drawing to full-color art, a useful technique in the advertising business. The last one, Demonstration 24, is done with marking pens, dyes, washes, and opaque designers colors. In the color section I have also included ten additional examples of mixed media. These paintings range from on-the-spot sketches to paperback cover assignments.

Pencil

Anyone interested in drawing normally begins by using pencil. As you develop as a painter or illustrator, you will always use a pencil for preliminary sketches or drawing studies for your paintings. It is a fundamental tool and a simple, convenient medium that requires only a bare necessity for its use: a piece of paper.

Very fine graphite drawing pencils are available at your local artist supply store. Eagle Turquoise, Koh-I-Noor, Mars Lumograph, and Venus are all very good brands. Drawing pencils use a lead grading system ranging from 9H, which is very hard, through to 6B, which is very soft. Grades F, H, and HB are in the medium range. I generally use an HB for much of my work, but prefer a 2H when drawing on a smooth surface such as bristol board. In addition to the regular drawing pencils, mechanical-type pencils are also available and special leads of varying grades can be used with them.

I use an X-acto knife to sharpen my pencils, pointing the leads with a sanding block. You may prefer to use a small pencil sharpener. There are many types of erasers and I'd suggest trying out a few to find the kind you like best. My favorite eraser is the kneaded rubber type, because it can easily be molded into any shape for erasing small, hard-to-get areas. Certain brands of pencils have eraser ends. Other types of pencils you will want to try are charcoal, litho crayon, and the Stabilo All. The last two can be used on just about any surface including acetate or mylar. The Stabilo pencil will also dissolve when water is washed over the drawing, creating an interesting effect.

Countless papers and boards can be used for pencil drawing. I personally prefer to work on a smooth, high-finish bristol board. Again, you will have to experiment with several surfaces until you find one you favor. Most papers are available in single sheets or the more convenient pads.

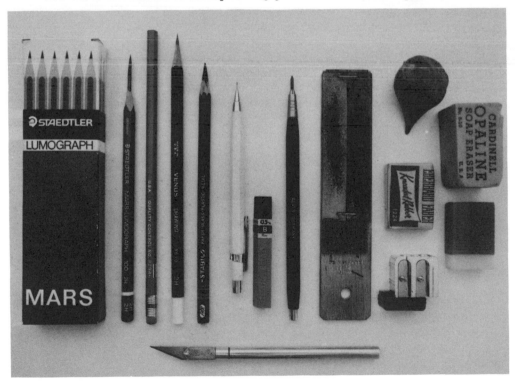

Here are some important tools. Pencils can be purchased in boxes of a dozen or individually. Mechanical pencils need not be sharpened, and the leads used in them are available in different grades. An X-acto knife, a small pencil sharpener, and a sanding block are useful. Many different erasers are on the market, but I think you may prefer the kneaded rubber type. I have shaped this one to a very fine point for erasing small areas or for picking out highlights.

For this group of exercises use an HB graphite pencil on a smooth high finish bristol board. Experiment by rendering various pencil textures on the board.

Using bold pencil strokes, try to render a blended tone ranging from dark to light. This kind of exercise will help you to gain control of the pencil.

Try to create an even gray tone through pencil strokes as I have done here. Try some very dark tones as well as lighter ones.

Now, render various gray tones, but keep them quite smooth, without any pencil stroke textures.

Draw a series of lines, closely spaced to create a gray tone. The line quality will vary according to how fast or slowly they were drawn.

Try to blend a very smooth tone ranging from very light to dense black.

For the next five exercises use a 4B charcoal pencil on a smooth, high finish bristol board. Draw some lines that vary in tone, from very light to quite dark, by controlling the pressure on the pencil.

Create a flat tone using pencil strokes. Try different tones, both light and dark.

Draw a series of lines very close together. Rub over the strokes with your finger or a rag, creating a smooth, even tone. Over this tone render a darker tone, trying to keep it very even.

Using pencil strokes, create a tone ranging from dark to light; start with long strokes, then very short ones. With your fingers or a rag, try to blend these strokes into an even, gradated tone.

Using horizontal strokes, create a tone that graduates from light to dark. Over this, on a small section, render a very dense, black area.

Experiment with a Stabilo All pencil on a smooth bristol board. The Stabilo pencil will dissolve when water is washed over the pencil lines.

Graphite Pencil on Smooth Bristol Board

This very simple pencil technique can be the basis for further development in this medium. After first establishing my composition with a rough sketch, I do a simple outline drawing of the scene on smooth bristol with a 2H pencil. The drawing is simply done, but quite accurate. Then, I just fill in the areas where I want the tones, using my compositional rough as a guide.

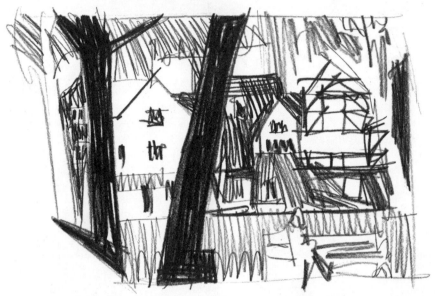

Step 1. *It is always a good idea to do a few rough sketches like this to establish your composition. A rough also helps you to determine exactly where your tones should go. I usually do this kind of drawing on tracing or layout paper, because it is transparent and therefore easy to make changes or corrections by simply tracing over your previous drawings. For rough sketching I prefer to use a softer pencil, such as the HB or 2B.*

Step 2. *Once I am satisfied with the composition, I do an accurate outline drawing, being careful to delineate all the necessary details in the scene. To do the drawing I use a 2H pencil.*

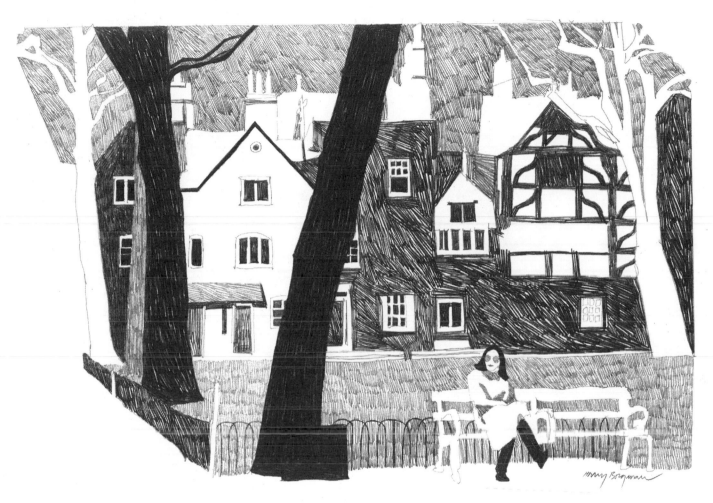

Jeanne in London, 13¾″ × 9½″ (35 × 24.1 cm)

Step 3. *Using my compositional rough sketch as a guide, I now render in the different tones of gray. I use a kind of textured tone by drawing in the areas with short strokes, without attempting to blend them together. I feel this bit of texture creates a little more interest in the drawing. This is drawn on a high-finish Strathmore bristol board, a very fine surface for doing pencil as well as pen-and-ink drawings.*

Charcoal Pencil on Regular Surface Bristol Board

Charcoal pencils are a little more difficult to use than regular graphite pencils because they are softer and tend to smudge, which is advantageous when the drawing requires lots of shading. To prevent smearing, I usually lay a piece of tracing paper between my hand and the drawing while I work. For this drawing I use a 4B Art Stroke charcoal pencil on a 4-ply regular surface Strathmore bristol board. The regular surface has a slight tooth or texture to it.

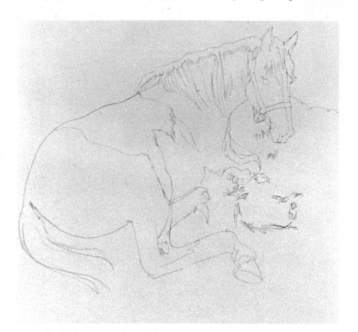

Step 1. *I start by doing a very light drawing with the 4B charcoal pencil. Notice that I start this drawing the same way as the first demonstration.*

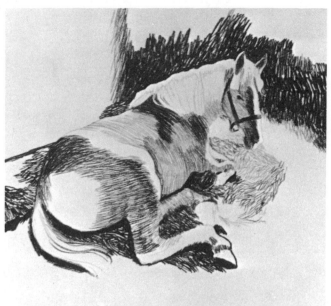

Step 2. *I establish a few of the darkest tones in the picture, which will help me to judge what the intermediate values should be. Now I begin putting some lighter gray tones on the horse. At this point, I leave parts of the drawing unfinished so you can get a better idea of the kind of pencil strokes I use. The direction of the pencil strokes follows the actual form of the horse, which helps to create the illusion of form. A good thing for you to remember. Notice that the strokes on the ground are of a different type; here, I am trying to give the impression of hay.*

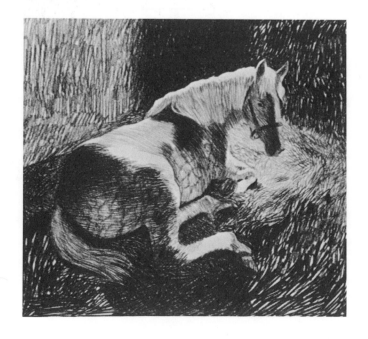

(Left)
Step 3. *I completely fill in the background, again being careful about the directions of the pencil strokes as well as the textures I want to simulate. I begin to finalize the background tones by going over the already-deep ones, further darkening the values of these areas. Notice, I do this above the horse's neck and in the lower portion of the drawing.*

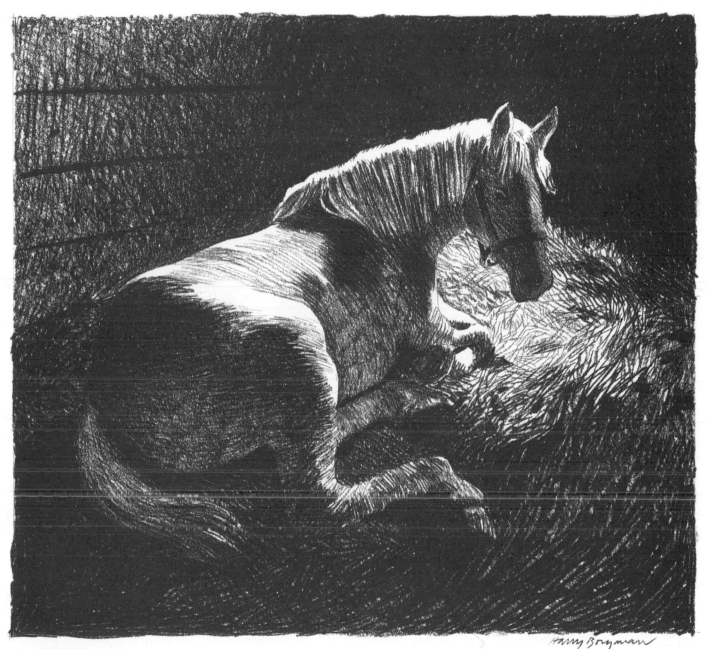

The White Horse, 14½″ × 13″ (36.2 × 33 cm)

Step 4. *After completely filling in the background tone, I can now finish the gray tones on the horse. This is a delicate stage of the drawing since it is nearing completion, and I must be quite careful not to overwork the drawing. Often, when I reach this stage of a drawing or painting, I will stop working and come back to it later with a fresh eye. It is a good idea to get away from something that you have been looking at so closely for a long time.*

After a little rest, I come back to the draw-

ing. I now begin to crisp up certain details, such as the harness, mane, and the tail, using a pencil that is pointed very sharply with a sanding block. A few of the tones on the horse's body are darkened slightly and the drawing is finished. Note that the tone values in this drawing range all the way from solid black to the pure white of the paper. When drawing with charcoal, a good way to keep the white areas clean is to use a kneaded eraser to remove any charcoal dust.

Stabilo Pencil on High Finish Bristol Board

I enjoy working with a Stabilo All pencil, especially on a very smooth-surfaced board. With this type pencil, you get a very black line and a different feeling than with a charcoal or graphite pencil. The Stabilo All pencil has a waxy lead, similar to a china-marking pencil except that you can sharpen the point much finer. Incidentally, lines drawn with a Stabilo All will dissolve a little when you use a wash of water over them, resulting in some very interesting effects.

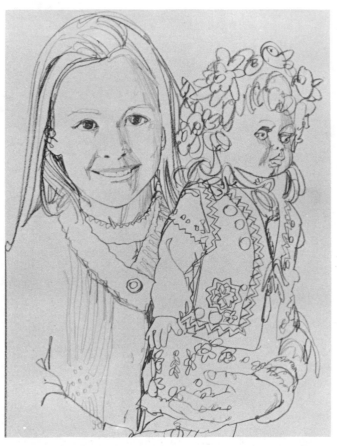

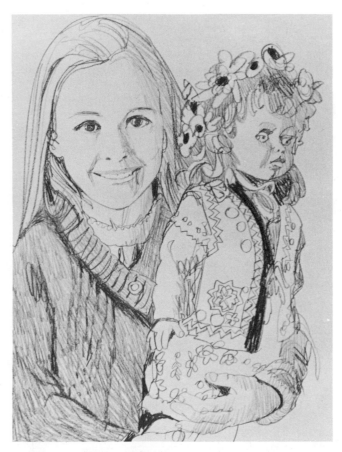

Step 1. *Again, I begin by drawing a linear rendition on Strathmore high-surface bristol board. The reference photograph is a 35mm color slide, which I project directly onto the board surface, then sketch over the image for my basic drawing. This technique is used frequently by advertising illustrators. Regular black-and-white photographs or other pictures can be projected with an opaque projector. See Part 4 for details about how this works.*

Step 2. *Now I spot in some of the blacks before adding any gray tones. The lighter intermediate tones are put into the face and hands, then a medium gray is applied to the sweater.*

(Right)
Step 3. *I finish the drawing by adding the rest of the blacks and just a few more subtle grays.*

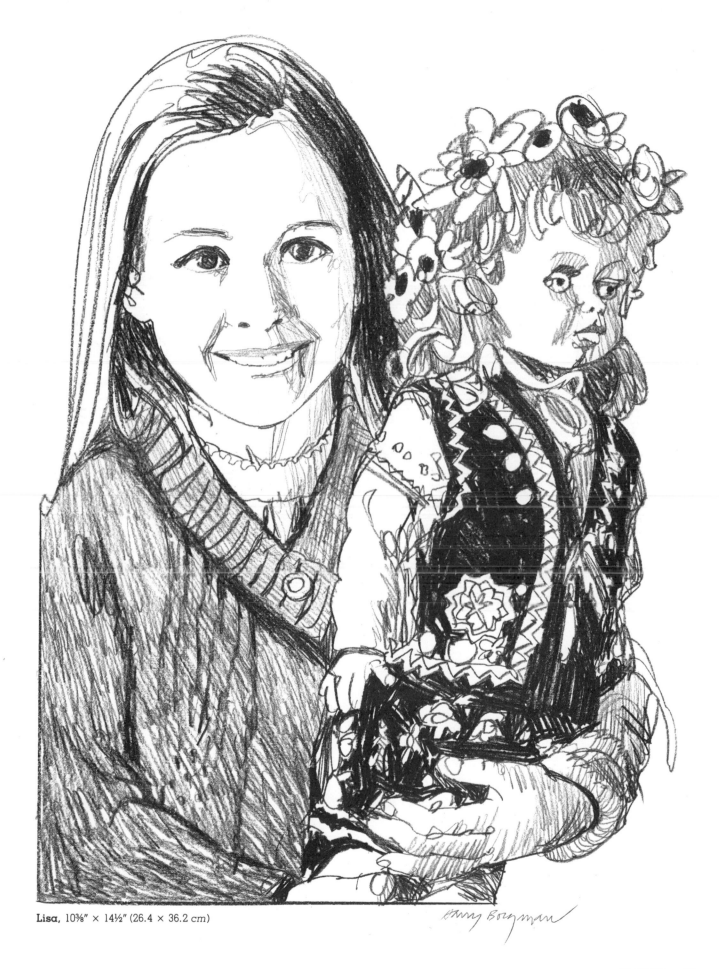

Lisa, 10⅜″ × 14½″ (26.4 × 36.2 cm)

Ink Line

Ink is a fascinating medium that encourages bold, direct work. With just a few simple lines, it is remarkable how much can be accomplished. It is a medium that encompasses countless drawing styles and methods of working, ranging from simple line drawings to complex cross-hatch renderings. As you practice and grow with this medium, you will probably develop a very personal style. At this stage, the important thing is to practice so you will become skillful with a pen and brush. The more you practice, the more natural drawing with a pen or brush will feel—as instinctive as writing with a pen or pencil.

In this section, I will introduce you to quite a range of techniques, but before you try any ink drawings, practice the exercises. This way you will quickly become familiar with the limitations and advantages of the pen and brush.

Knowing your tools well will give you a measure of confidence that will most certainly help you to produce better work and advance more rapidly. To start, get a crowquill pen, either a Gillott 659 or a Hunt 102, a pen holder, a bottle of India ink, and a pad of smooth bristol board. For brushwork, buy only the finest quality red sable brushes, since the cheaper variety will not hold up or even work very well when new. A No. 3 or 4 brush should be about right for doing most drawings.

As you advance, you will need some other drawing tools. I would suggest a technical pen with a fine point, a very handy instrument for outdoor sketching since it carries its own ink supply. I would also advise purchasing a variety of different pen points, so you can experiment with them. If you want to study ink techniques further, my previous book *Drawing In Ink*, published by Watson-Guptill, covers line and wash techniques as well as specialized ones such as scratchboard.

Here are some of the inks, pens, and other tools I use for ink drawings. An amazing variety of pen points are available. I would suggest that you try several types to see which kind works best for you. Before you buy a pen holder, hold a few to see which type feels good in your hand. To start, though, all you will need are a crowquill pen and holder, a bottle of India ink, and a sheet or a pad of smooth bristol board.

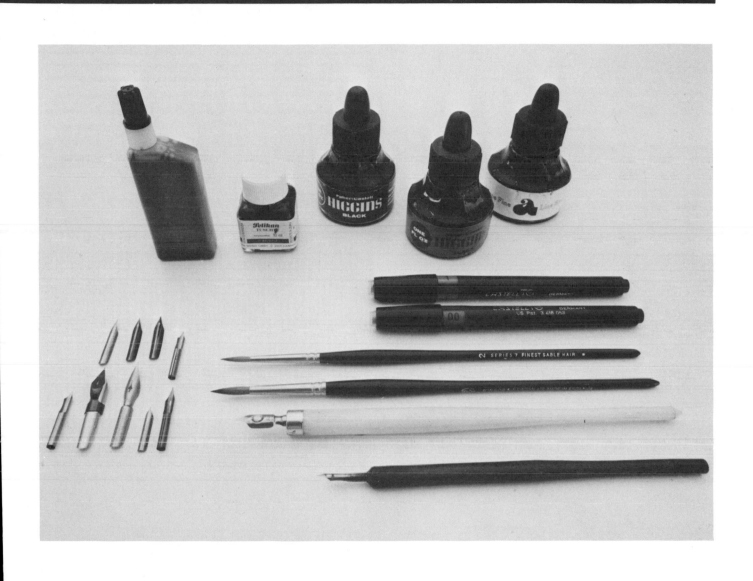

On a piece of smooth surface bristol board, practice these exercises with a crowquill pen. Draw various lines, fine and heavy, some drawn quickly, others slowly.

Practice drawing a variety of lines, including some with a texture.

Practice drawing horizontal lines until you can draw them closely, without touching one another. Try this using a few different pen points.

Follow the last exercise, this time using vertical lines.

Draw many lines of varying weights by increasing and decreasing the pressure on the pen point as you draw.

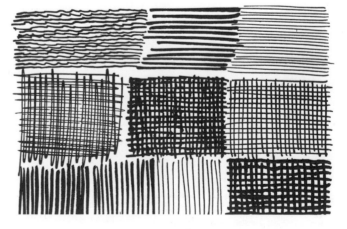

Try to create different tones from a series of lines. The lighter your lines, the lighter the tones will be.

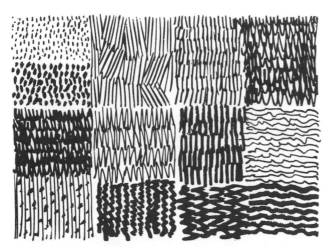

Draw many different textures, using pen strokes. Here are a few to start with.

Practice drawing even, ruled lines by bracing your pen holder against a ruler. Try the same thing using a brush. This is an important and useful exercise.

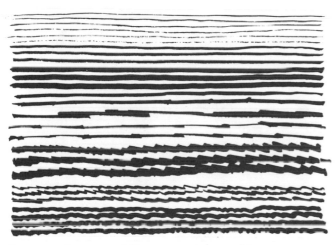

Practice drawing different strokes and lines using India ink and a high quality red sable No. 3 brush.

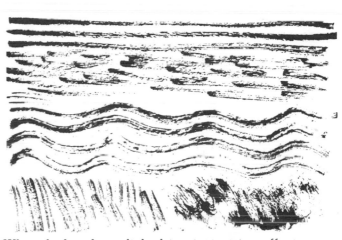

When the brush is a little drier, interesting effects can be achieved.

Practice drawing straight lines of even weights, then draw lines where the weights vary from light to very dark.

Draw brush textures and tones that graduate from light to dark. Try the same thing using the pen.

Loose Ink Line on Smooth Bristol Board

Of the many ink styles and techniques, I favor a loose rendition as I have used in this demonstration. I often use a fine-pointed technical pen for this type of drawing. For the black accents, I sometimes use a brush or a pen that draws a heavier line, such as a Speedball lettering pen. Speedball pens come in a great variety of styles, weights, and points.

Here, I use smooth-surfaced bristol, which has no surface texture, so your pen will glide smoothly across without snagging. Lightly-textured boards also work very well for pen drawings, but you must be a little more careful when working. This drawing is done from photographs taken at a rodeo. In one of the later color demonstrations, I use other photos taken the same day.

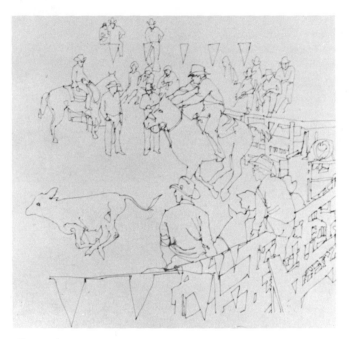

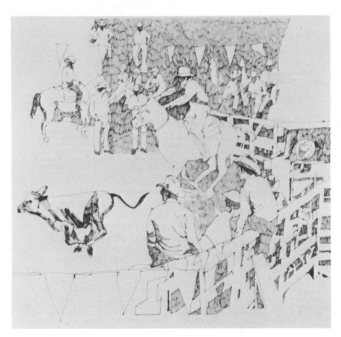

Step 1. *I start this drawing the same way the pencil demonstrations were started, that is, by doing an outline drawing of the scene. I use a Castell TC technical pen with a 00 point, which enables you to draw with a very fine line. This type of pen is just great for doing ink drawings, especially when sketching outdoors since it carries its own ink supply.*

Step 2. *Using the same pen and short, quick strokes, I add the middle gray tones throughout the picture. Rather than end up with a square shape to this drawing, I decide to have a more interesting outside shape by limiting the tonal areas as you see here. This was not actually planned, but something that developed as I worked.*

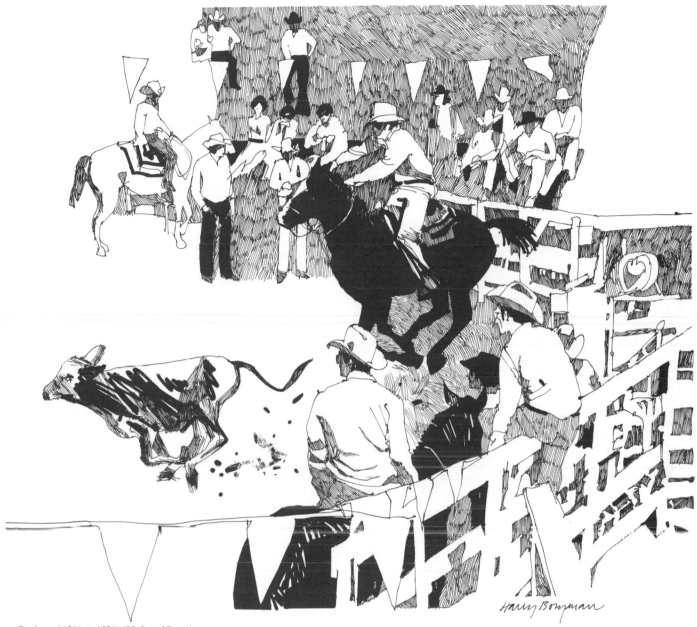

Rodeo, 11¾″ × 10⅝″ (29.8 × 27 cm)

Step 3. Using a Speedball B4 lettering pen point, I now begin to spot the blacks in the picture. Since there are so few middle gray tones in this drawing, I did not have to put in the blacks first to help me establish the gray, middle tones, as I did on some of the previous drawings. This particular Speedball pen point draws a rather heavy line and consequently, large areas can easily be filled in if necessary. I like the way this pen's heavy line contrasts with the finer line of the technical pen. This contrast helps to create a more interesting picture. Note how well the combination of the two pens works on the rendering of the calf. It's done quite loosely, and this actually helps to convey the action of the scene. To finish the drawing, I add a few ground textures.

Brush Drawing on Watercolor Paper

Drawing with a brush usually seems quite difficult to the beginner, but like everything else, it just takes practice to learn how to use it properly. The brush is most important since it is the basic tool you will use when painting in other mediums. Once you gain the necessary control, you will see the advantages to drawing with a brush. You can work with greater freedom, creating a much looser line than with a pen. With a little practice, you'll soon be making the brush do what you want it to.

One of the most important things I should stress here is that it is very important to use only the highest quality red sable brushes. Cheap brushes are a waste of time and money. A good brush is much easier to control and, with proper care, will keep a point for a long time. Occasionally, you should wash your brushes with mild soap and water, to clean any ink or paint that has accumulated near the ferrule.

Step 1. *Using a No. 4 Winsor & Newton series 7 red sable brush, I draw the scene in outline on a sheet of watercolor paper. The rough surface of the board gives the line an interesting texture. As I continue to draw, some of the tree branches also create a textural tone.*

(Right)
Step 2. *It does not take much to finish this drawing, I simply fill in the tree trunks with the ink. Because of the roughness of the paper, a little white shows through on the trunks. This is a very simple type of drawing that can be done on-the-spot. It is also very good training for learning how to use the brush. Doing quick drawings like this will prepare you for working in watercolor.*

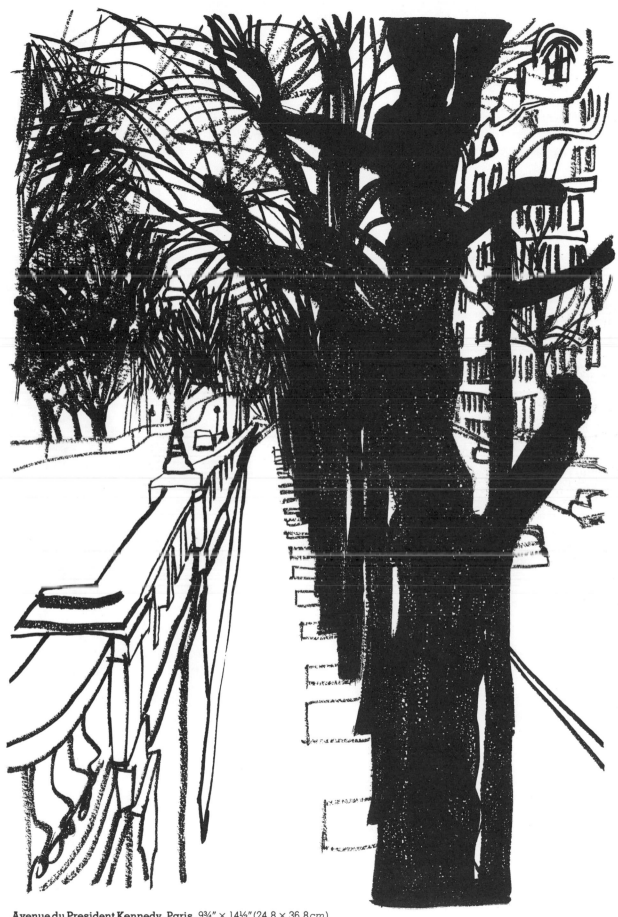

Avenue du President Kennedy, Paris, 9¾" × 14½" (24.8 × 36.8 cm)

Crosshatch Pen Drawing

There are many different ways to add tones to ink line drawings. A very useful method that is easy to learn is crosshatch. By drawing lines over lines, you can create different tones of gray, depending how close together the lines are drawn. Two important factors are how thick the lines are, and how many times they are drawn over one another. It is best to keep crosshatch drawings simple, because a good drawing can be ruined by overworking—which is true, of course, in many mediums. This drawing was done from a 35mm color slide taken on a visit to the ancient walled city of Carcassonne in southern France—an absolute must on your itinerary if you ever visit France.

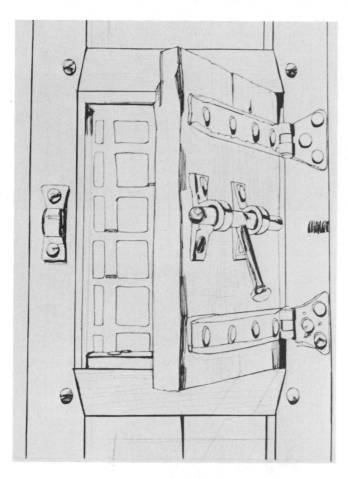

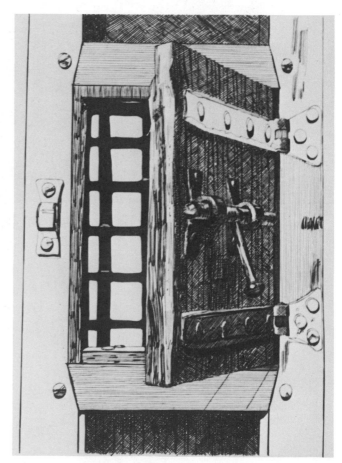

Step 1. With a 2H graphite pencil, I begin by rendering an accurate pencil drawing on Strathmore 4-ply, regular surface bristol board. This is done by projecting my 35mm reference slide directly onto the board. I do this drawing quickly since it is really more of a diagram to use for the ink rendering. Then, using a No. 659 Gillott crowquill pen, I begin to ink the drawing, outlining all the various objects and details.

Step 2. On the shadow side of the small open door, I start to add gray tones, by first drawing lines in one direction. Then, over these lines I draw in another group, but at a 90° angle to the first group. This creates a dark tone that seems to work well in this area, but it is a little early to be sure. As other tones are added to a drawing, the tones that are already drawn in often appear too light.

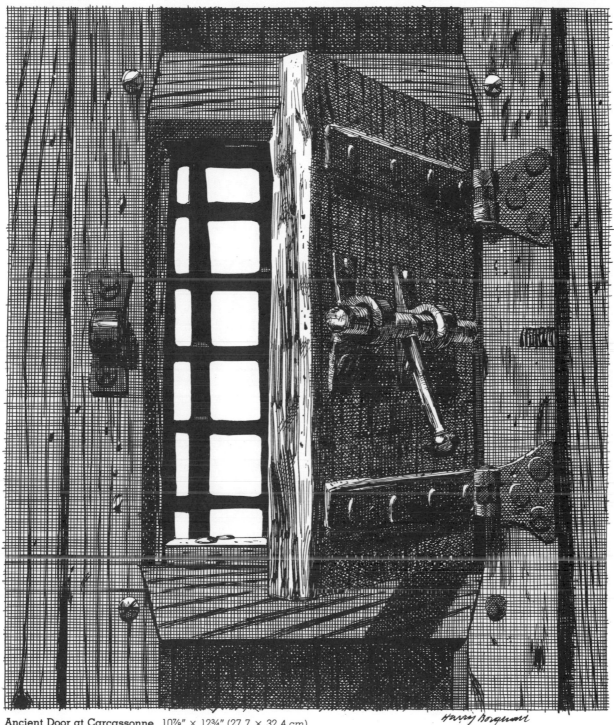

Ancient Door at Carcassonne, 10⅞" × 12¾" (27.7 × 32.4 cm)

Harry Borgman

Step 3. *Still using the Gillott pen I slowly build up the gray tones in the wood and on the various details such as the hinges and bolt-heads. I work over the whole picture area, rather than finish up any one section. In this way, the drawing comes together gradually, and there is less of a chance to overwork certain areas. Notice that many of my lines are rather straight; I do this by resting the pen holder on the edge of a ruler, then ruling the lines carefully in. (I show how to do this in the exercise section, page 39.)*

Textures and wood grain are drawn in for added realism. At this point, the shadow side of the door appears too light, so over this area I draw an additional set of lines in a horizontal direction, which darkens the door sufficiently. However, now the other wood areas look too light, so I darken these tones also.

When rendering a crosshatch drawing, I should mention that if you are not working with good photographic references, you should always do preliminary tone sketches to follow.

Ink Tone

Another way to add tones to ink drawings is to use water-soluble ink washes. A basic ink drawing, if done with India ink, will not dissolve when you add the washes. You can also render sketches and paintings by just using the water-soluble ink, without first doing a line drawing. Generally speaking, ink washes work best on a surface that has a slight texture such as cold-pressed illustration boards and rough-surfaced boards.

To work with ink washes, you'll need a bottle of Faber-Castell Higgins non-waterproof, soluble India ink. A small, partitioned mixing tray or even a ceramic dinner plate can be used to mix the wash tones. You'll need a couple of brushes, No. 4 and No. 6, but use only the highest quality red sable. A wider, soft-haired sign-painter's brush is good for wetting large areas or painting washes. A sheet of 4-ply Strathmore regular surface bristol board, or any other good cold-pressed illustration board, will work well.

In this section, I will show you how to use various ink wash techniques: ink wash over line drawing, ink tone wash drawing, ink washes with water-soluble ink. Be certain to practice the exercises before you begin an illustration or painting.

You will need a mixing tray, preferably one with separate partitions, but even a ceramic plate will do. You will also need a bottle of waterproof India ink, a bottle of water-soluble ink, and a couple of sable brushes—a No. 3 or 4 and a No. 6 or 7. Remember to only use high-quality brushes.

Try painting tones that gradually get darker. Begin with a very faint tone, and add a little drop of water-soluble ink for the next tone. Try to get each tone just a little darker than the previous one.

Now try to blend a wash tone, ranging from dense black to nearly white. Wet the board surface first with clear water for best results.

Paint a flat tone, and while this is still wet, paint over it with some undiluted water-soluble ink.

Paint another flat tone. When it is nearly dry, paint over it with tones of water-soluble ink and the waterproof ink. Compare the two types of ink when dry.

Wet your board surface with clear water. While this is still damp, paint globs of water-soluble ink over it. Do the same thing using waterproof ink. Study how the two different inks react.

Paint a light, flat wash tone with the water-soluble ink. When this tone dries, paint over it with darker tones of the same ink. Before it thoroughly dries, drop a little clear water on it to see what effects are created.

Over a flat, light tone of water-soluble ink that has not quite dried, paint a little waterproof India ink. Notice that the waterproof India ink spreads less than the water-soluble ink under the same conditions.

Wash a light tone, using water-soluble ink. With the same ink, undiluted this time, darken the tone here and there. Then, paint a little clear water over some areas. A lot of strange, unpredictable things can happen when you do this, but often the clear water spreads into the darker wash tones, lightening them.

Ink Washes over Line Drawing on Rough Watercolor Board

This is a simple ink wash technique to start with. It is basically just an ink line drawing to which wash tones have been added. I use a similar technique when sketching on-the-spot. Some-times, I just do the ink line drawing on location and add the washes later in my studio or hotel room, if I'm traveling.

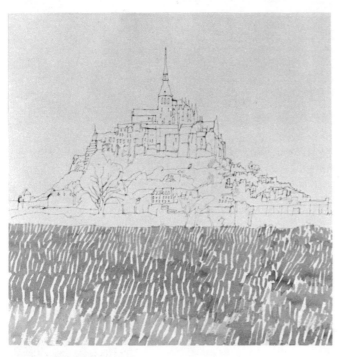 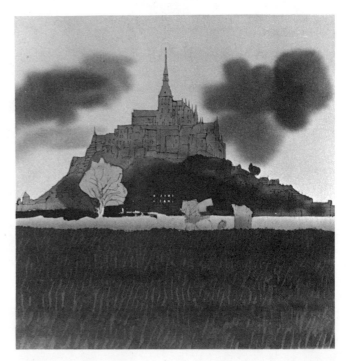

Step 1. First, I do a line drawing of the scene using a technical pen on a sheet of rough-surfaced watercolor board. Then, I begin paint-ing by washing the ink tones on the foreground, using strokes to create a texture. The wash will not dissolve the original drawing since I'm using waterproof India ink.

Step 2. When these tones are dry, I wash clear water over the whole board surface with a 1½" (4 cm) sign-painter's brush. Then, with water in the mixing tray, I dilute a little of the water-soluble ink. This light tone is washed over the dam-pened paper surface. Before the paper dries, I quickly mix up a darker tone to brush in the cloud shapes in the sky. To keep these cloud shapes from spreading too much, I dry the paper surface with an electric, hand-held hair dryer. Now I brush a tone over the foreground and on the town itself.

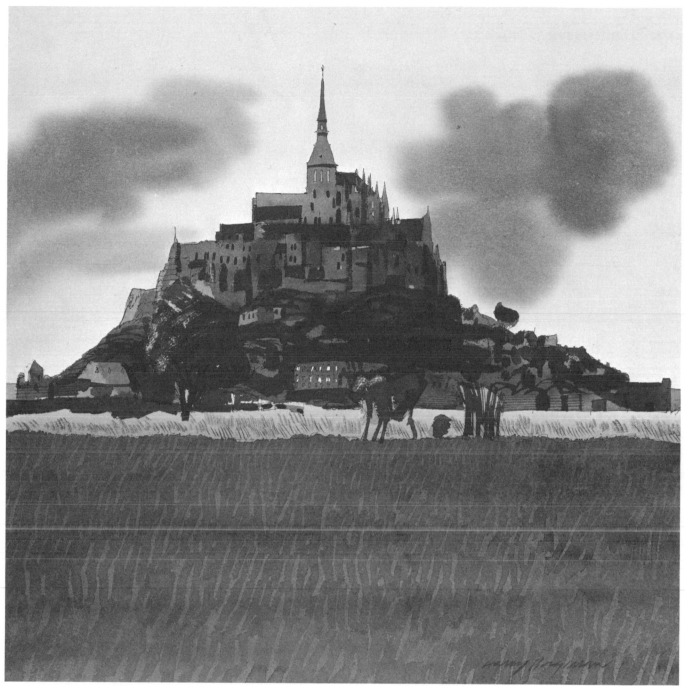

Mont Saint-Michel at Dusk, 15″ × 15″ (38.1 × 38.1 cm)

Step 3. Gradually, the town area is darkened, black accents spotted throughout. I add a slight drybrush texture to the lighter portion of the background field, using India ink with a No. 3 brush. A few textures are put in the trees by scratching through to the white paper with an X-acto knife.

Ink Tone Wash Drawing

The effects of drawing with ink and a brush are quite different than with a pen: Drawing with a tone line is an interesting technique you should try. The best results are obtained on rough or cold-pressed surfaces, and you can use the same materials from the last demonstration. This is another very fine technique for doing on-the-spot sketching.

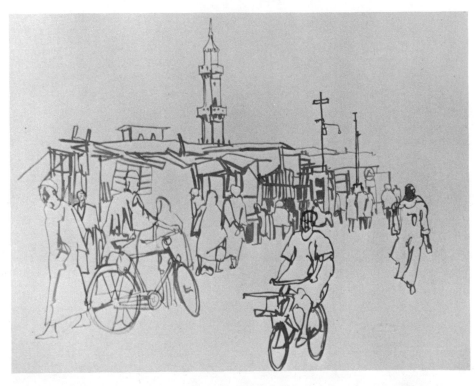

Step 1. *To begin, I use a Winsor & Newton No. 3 brush, and with water-soluble ink I draw directly on a 4-ply regular surface Strathmore bristol board.*

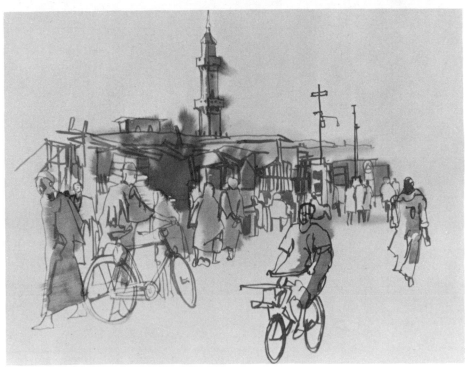

Step 2. *After my basic drawing has dried thoroughly, I dampen the whole board surface with clear water, using a large 1½" (4 cm) brush. This will not dissolve the previous drawing, since the ink has soaked well into the surface. I quickly add a wash tone over the sheds in the background and on the people. I make no attempt to paint flat tones, but, rather, freely spot in the tones, letting them blend together. I let the washes run over and outside the edges of the drawing.*

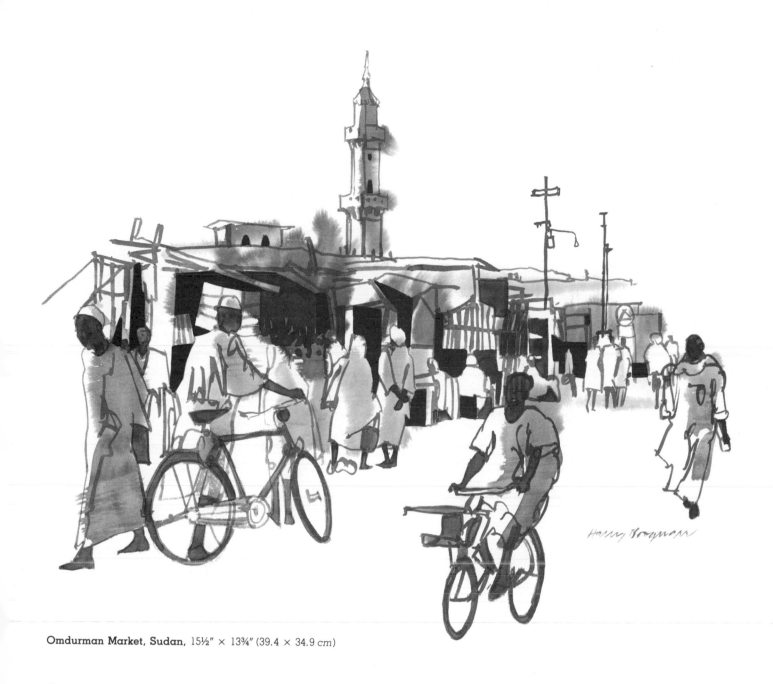

Omdurman Market, Sudan, 15½″ × 13¾″ (39.4 × 34.9 cm)

Step 3. *When the surface is thoroughly dry, I add more tones to the figures, then spot some darker grays into the background. The black accents are put in with India ink.*

Ink Washes with Water-Soluble Ink

While Demonstration 8 was an example of a loose, spontaneous technique, this illustration is more carefully planned, yet handled in a flat, simple manner. Before starting the actual drawing and rendering, I first make a couple of pencil sketches to establish my composition and gray tones. This example is handled in a flat, simple manner that could be developed into a more realistic rendition by adding more tones to create dimension. This demonstration was rendered with only two tones of gray and black.

Step 1. *Using a No. 5 Winsor & Newton series 7 brush and Higgins water-soluble ink, I draw directly on a sheet of 4-ply Strathmore regular surface bristol board. I start to add a gray tone in the background over the foliage.*

Step 2. *With the same brush, I paint a medium gray tone over the figures. Then, I wash a darker gray tone over the background trees with a No. 10 brush. When this tone dries completely, I add leaf and other tree textures, using water-soluble ink.*

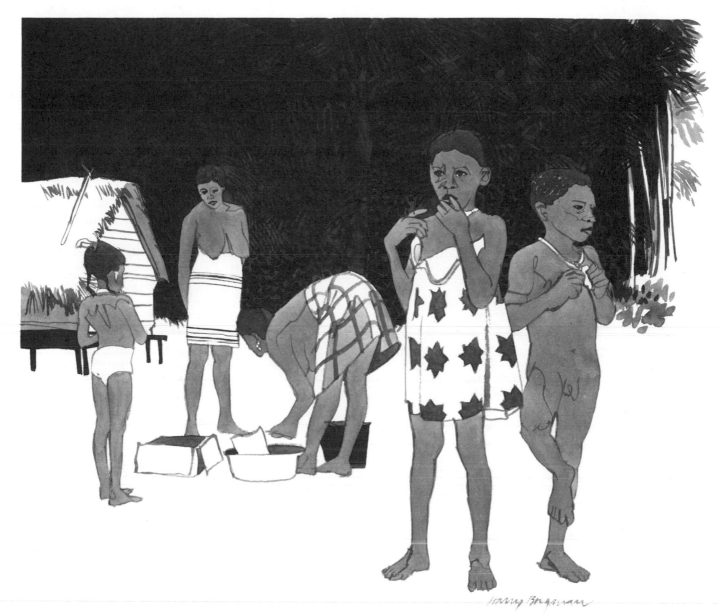

Village of Onekai, Surinam, 14″ × 12″ (35.6 x 30.5 cm)

Step 3. *Darker tones are painted on the hair, and additional black areas are added such as the basket behind the central figure and on the platform under the hut. I finish by painting in a few simple patterns on the clothes.*

Markers

For the beginner, markers are probably the easiest and quickest way to get started working in color. An ideal medium for quick sketches, drawings, or even paintings, markers are used extensively in advertising for roughs, comprehensive layouts, and TV storyboards.

Because they dry so rapidly, markers are useful for preliminary sketches and color studies. In addition to being quite versatile, they are available in an endless color range, are compatible with other mediums, and work well on most painting surfaces. A most important advantage is their convenience: you need no mixing trays, brushes, or water bowls, thus eliminating time-consuming cleanup.

Markers are available in all shapes and sizes, so you will have to decide which type you will want to use. Be sure to select a brand that offers an extensive color selection and range of tones. See what your local artist supply store has to offer in the way of markers. Purchase one or two brands that feel right in your hand, then try them out at home. After working with a few, you will probably prefer one brand over another. I use the Magic Marker Studio brand, which offers 186 different colors that are available in sets of twelve. These color sets include: basics, primaries, complementaries, intermediaries, skin tones, warm or cool grays, and others. If you would rather not buy a set, I would suggest you start with the following: vermilion, flesh, pale sepia, crimson, lemon yellow, pale blue, blue green, mariner blue, Nile green, aqua, pale olive, mustard, Nos. 2, 3, 5, 7 warm or cool grays, and black.

The Magic Marker bottle can be opened, and the inside fibrous material containing the color can be removed. I use this core to paint very large areas of color smoothly—something that is difficult to do with the normal nib.

There are other excellent brands of markers: Ad Markers, Design Art Markers by Eberhard Faber, and the Pantone Color Markers by Letraset—all have a fine color range. Markers work well on most paper surfaces, but layout and tracing are the best types to use. High surface bristol boards work quite well too. Do the exercises and try out the markers on many different surfaces, then you will have a good idea which paper or board surface you prefer to work on.

If you are interested in further pursuing marker techniques, the subject is covered quite thoroughly in my book, *Landscape Painting with Markers*, also published by Watson-Guptill Publications.

(Below)
Markers have many different shaped nibs; the standard one is multi-faceted and wedge-shaped, made from a felt material. Other useful nibs are the fine-pointed variety; these are usually made of nylon or plastic.

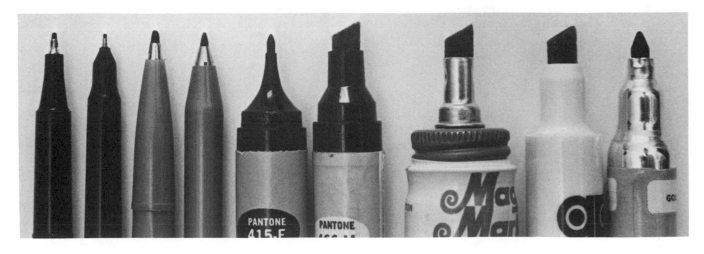

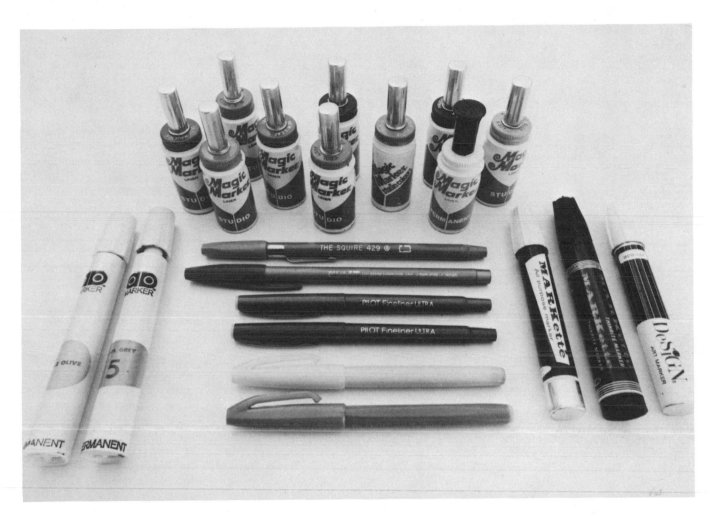

Here are a few of the marker products I use. Ad Markers are available with the standard wedge or a fine-pointed nib, offering a good color range. Magic Markers, the ones that I usually work with, are available in 186 different colors. They are also available with two kinds of nibs—the standard and fine line. Other marker pens that I find quite useful are the Pilot Fineline and the Pentel Sign pen. The Eberhard Faber Design Art Markers and Markette pens are available in wedge, bullet-shaped, or fine pointed nibs.

The first four exercises are done using markers on layout paper. Try to render a very flat, even tone of color or gray. For best results work very quickly.

Do a flat color tone, then go over it with another color. While this is a little damp, go over the area with another color. You will begin to see how markers react over one another on this particular paper.

Cover an area with a flat tone of color. Quickly, while the tone is still wet, stroke another color over the tone and on the surrounding area. The strokes spread more over the color tone. The amount of spreading depends upon how dry your marker is.

Over a light color tone quickly stroke in three or four other color tones. This will help you to understand how various colors react over one another.

The next four examples are done on tracing paper. Render a flat, even tone; go over this with another color. While damp, stroke lighter colors over these tones. The lighter colors dissolve the darker tones.

Render a flat tone of color. When this is dry, stroke over several darker and lighter colors, taking note of how these strokes dry with hard edges.

Render a flat, even color tone; then, stroke over another color. Over this, draw with a Markette pen or a Design Art Marker (bullet-shaped nib type). Using a lighter marker, cut back into the tones and lines.

Over a flat color tone, draw lines with the Markette pen and a Pentel. When they are dry, go over the area with a lighter colored marker. The Markette pen lines will dissolve more than the Pentel pen lines.

The next two exercises are done on a smooth surfaced bristol board. Render a flat, even color tone—do this quickly to avoid hard edges. Go over it with darker colors, then a lighter one. The lighter color does not dissolve the darker colors as on tracing paper.

Draw with a black marker, Pentel, and Markette pen over a flat tone. When dry, go over this with a light colored marker. Because of the ink penetration into the paper surface, the lines will not dissolve much.

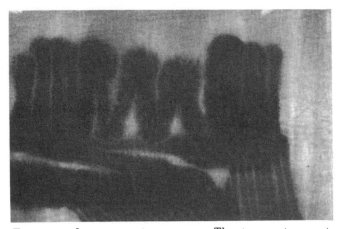

Try using Japanese rice papers. The tones stay wet longer and spread more than on other papers.

Draw various lines on the rice paper with a black marker and various other marking pens. Draw slow strokes as well as quick ones and study the results carefully. Also try this using color markers and pens.

Markers on Tracing Paper, Portrait

When you first begin with markers, I would suggest using layout or tracing paper, which is available in different size pads containing 100 sheets. On layout paper, the marker colors soak into the surface; consequently, colors cannot be lightened. However, the surface of tracing paper is less absorbent, thus allowing you to change values by going over darker colors with lighter markers. This cannot be done on most papers.

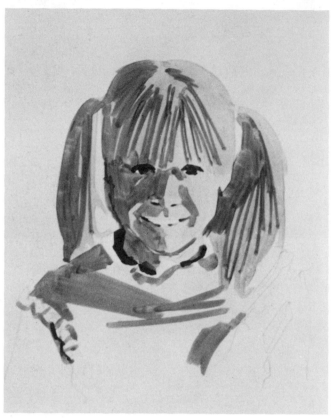

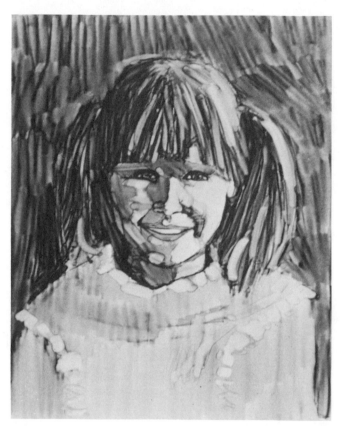

Step 1. *Using an F graphite pencil on a good quality tracing paper, I do a loose drawing of the girl. You can do several drawings by tracing over your previous drawing and making any changes or corrections—until you get everything right.*

I block in the hair with a pale sepia marker, and apply flesh color to the face. A few of the shadow tones are blocked in with a No. 6 warm gray, and the darkest tone is put in with a No. 9 warm gray.

Step 2. *I keep working over the highlight areas of the face, cutting back into the tones with flesh color and oriental. On the shadow side of the face, I use walnut and terra cotta, then put a tone of light suntan over this.*

I work back and forth, between the highlight and shadow tones, until the face starts to take shape. Since the marker inks do not soak into this paper surface, I move the color around by dissolving the tones with wet markers until I get the desired effect. However, this is not easy, but I keep trying, and finally it takes shape. I add a No. 9 warm gray to the eyes and to all the deeper shadow areas. Vermilion and a light No. 2 gray are put on the dress, over which I use oriental. The background is painted in with Prussian blue, which I go over with oriental.

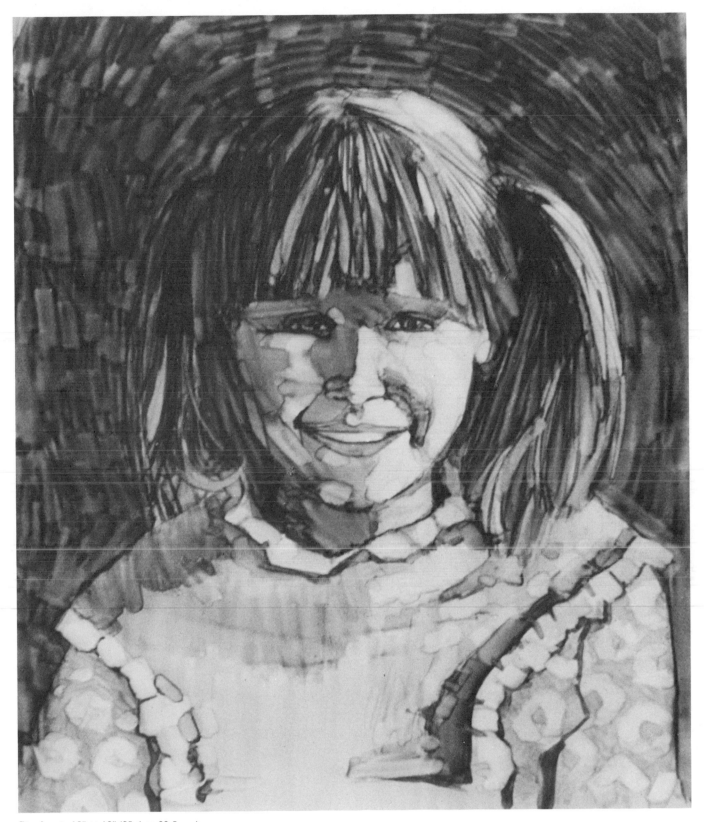

Stephani, 10″ × 12″ (25.4 × 30.5 cm)

Step 3. *I add the No. 9 warm gray to the girl's hair and use mustard for the highlights. I pick out the flowers on the dress with a No. 2 gray. Then, to warm up the whole background, I go over it with sanguine. Methyl violet and lilac are used for a shadow on the pinafore. A few last-minute highlights are put out on the face with a flesh marker.*

Markers on Tracing Paper, Mechanical Subject

In this demonstration, I show you how to apply the same technique from Demonstration 10 to render a mechanical subject. This is a race car scene, and markers work very well for the type of rendering that must capture a lot of action. For reference, I used magazine photographs of race cars, combining several to create this composition. This required several sketches, but you always should work out your composition before you actually begin the final rendering.

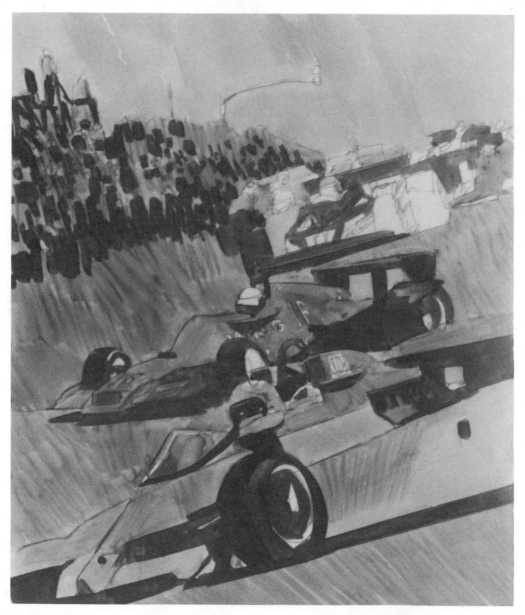

Step 1. I do a loose but accurate drawing on tracing paper with an HB graphite pencil. When I am satisfied with the basic drawing, I begin by filling in a few color values, being very careful not to lose my drawing since markers dissolve graphite. I use a golden yellow on the foreground car and vermilion on the racer in the middle ground. Various shades of blue and pur- ple, orange, and green are used for the background cars. All these tones are put in very quickly, just to establish a general color in these areas. Lilac is painted over the road, and a No. 5 warm gray is put over the crowd in the background. I now add a pale sepia to warm the road up a little. Some of the deepest shadow tones are rendered with a No. 8 warm gray.

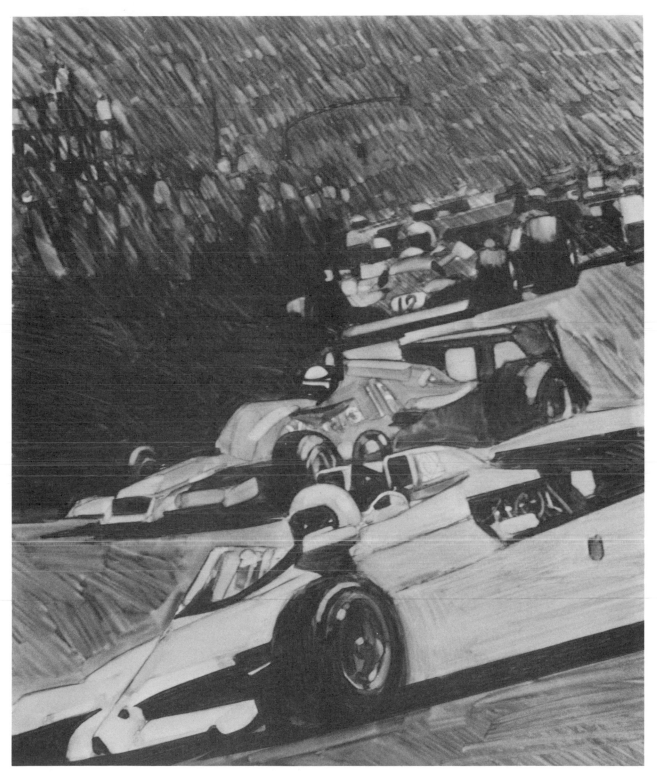

Step. 2. *Over the whole background I add a No. 6 warm gray, using short, quick strokes to create a texture. Over the dark shadow areas I use Prussian blue. Now, I put a terra cotta over everything except the race cars. This warms the overall color considerably and the picture seems to be progressing very well at this stage. By using light colored markers such as flesh,* *pale blue, and yellow, I cut back into some of the darker tones to create highlight effects. I use this technique to add some detail into the crowd area, bringing out some of the figures. Using a No. 9 warm gray, I sharpen up some of the shadow areas as well as a few details in the race cars.*

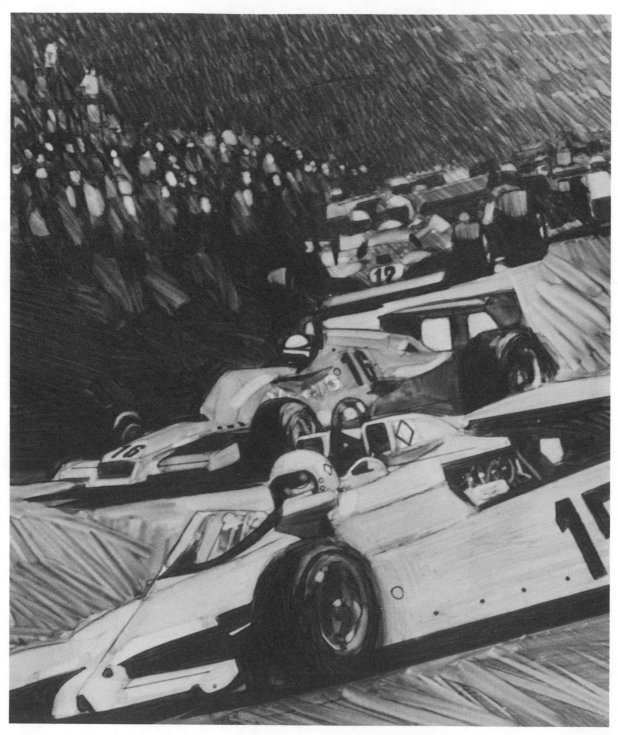

Step 3. With the flesh color I carefully pick out light spots in the crowd, creating the impression of faces and clothing. For the shadow tones in the crowd, I use a No. 9 warm gray. The sky is darkened considerably with a No. 8 warm gray, and I break up the road tone with a light suntan, creating a more interesting texture. More details are added to the cars as well as the numbers.

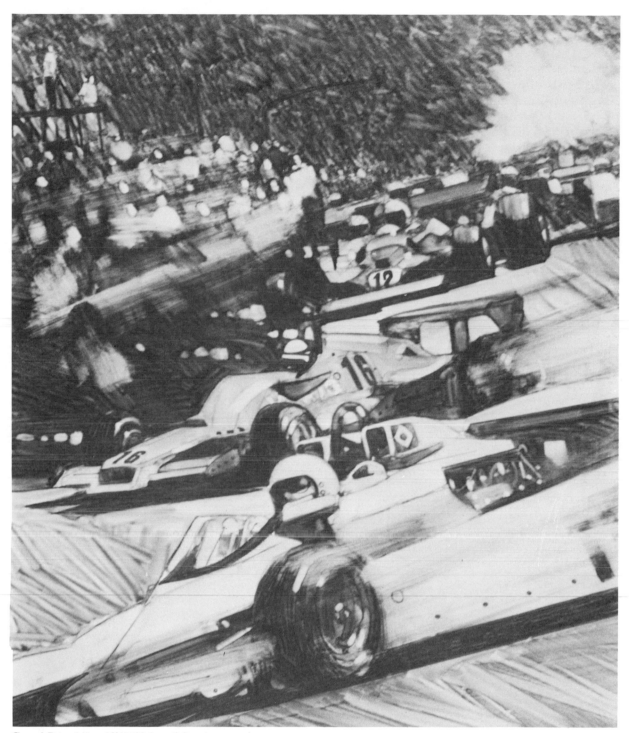

Grand Prix, 14" × 16½" (35.6 × 41.9 cm)

Step 4. *Using a rag dampened with Bestine, a rubber cement thinner, I wipe over the crowd until the color dissolves a little. The smeared effect creates a feeling of motion. I like the result and decide to try the same thing over the foreground cars, blurring the wheels. This adds quite a bit of motion, which is so important in this picture. In the background, I now dampen an area with a light suntan marker; then with a rag, I quickly wipe the color away before it dries. This* *gives the effect of dust and smoke, adding still more action to the illustration. When working with markers on tracing paper, do not be afraid to attempt affects such as the ones I have used here. If they do not work, you can always put your tones back in and try again. Realizing that your painting will not be a total loss if you make a mistake can give you confidence. For the final touch, I add olive green to the background to give the impression of foliage.*

Markers on Smooth Bristol Board

In this demonstration, I use a different paper surface: a Strathmore 4-ply regular surface bristol. This board has a slight surface texture, and I use it frequently for ink drawings. Another bristol surface that works very well with markers is the smooth, high finish type, which can also be used for ink drawings. Unlike tracing paper, the bristol board surface is absorbent, and the markers will soak into the board. Therefore, you cannot lighten dark areas by using light-colored markers over them. Consequently, be very sure about what colors you are going to use and how dark they should be. The rule for this kind of a paper is that you can always darken your colors, but never lighten them.

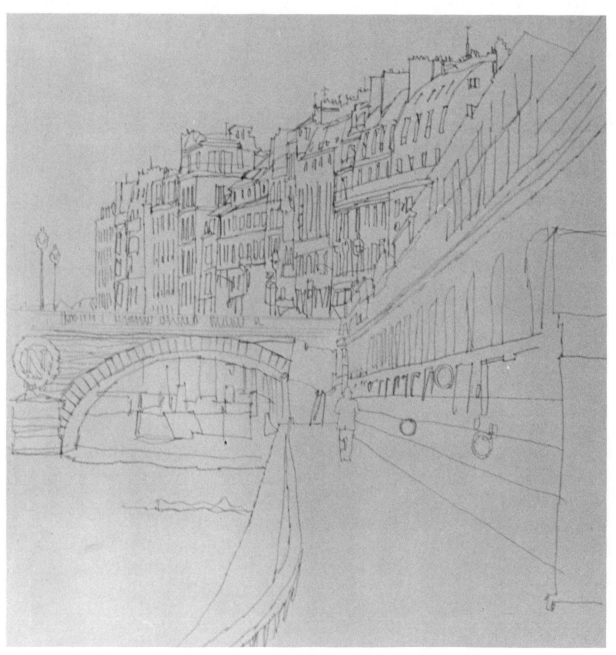

Step 1. *First, I draw this scene on a regular surface bristol with a 2H graphite pencil. Since the marker inks will dissolve graphite pencil, I spray the finished drawing with fixative, which will prevent the lines from smearing when I use markers over them.*

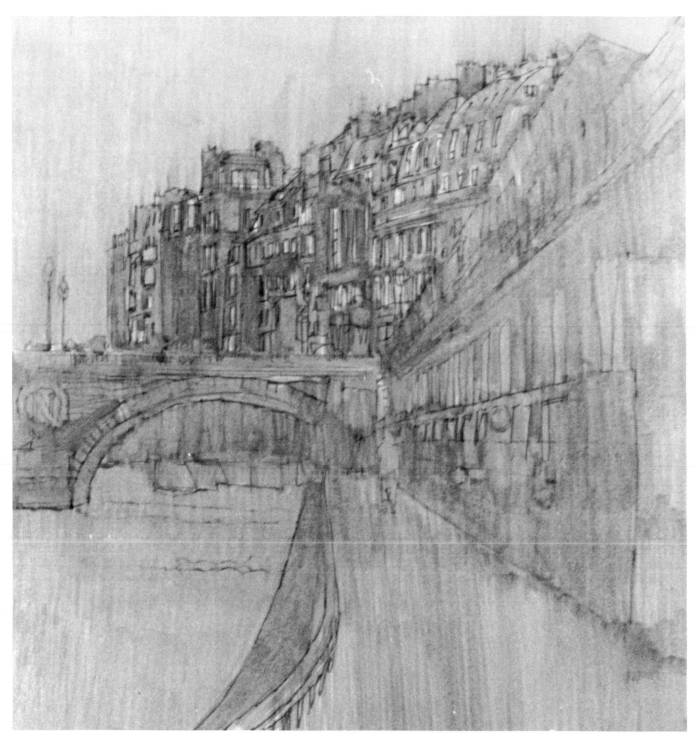

Step. 2. *I apply flesh to the sky and the water area. On the buildings, I use No. 3 warm gray as well as a few other subtle colors such as brick* beige, pale blue, and putty. I add some brick beige over the sky and water.

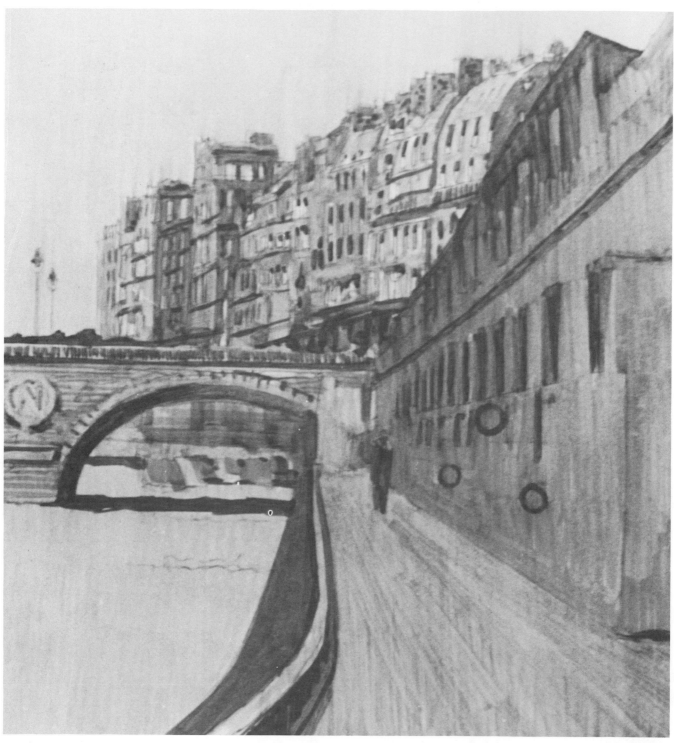

Step 3. Using a No. 4 warm gray, I add a tone over the background buildings and on the wall in the foreground. With Nos. 7 and 8 warm grays, I paint in the dark accents in the windows and other shadow areas. A tone of flesh is now put over the quay area. Many details, such as the railings, shadow under the bridge, and on the buildings, are now added with a No. 7 cool gray.

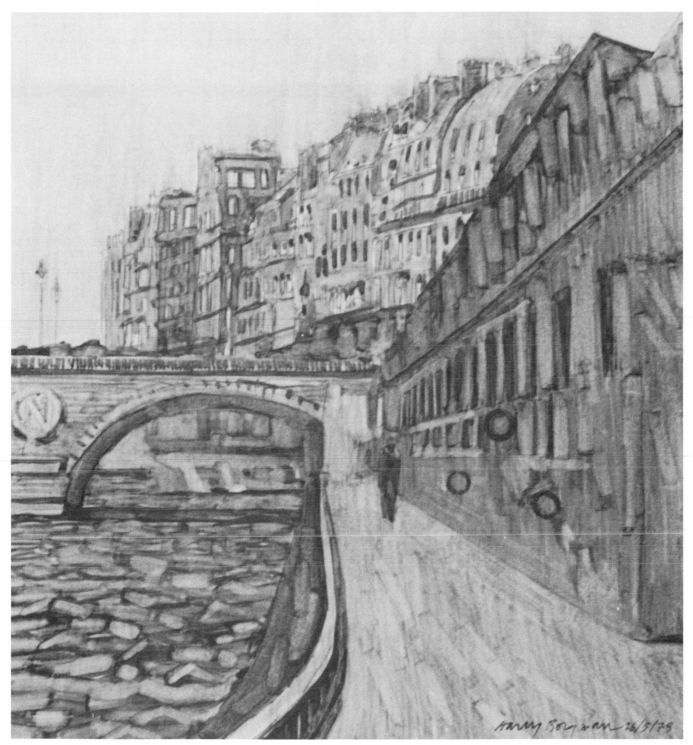

Along the Seine, 11⅝″ × 12½″ (29.5 × 31.8 cm)

Step 4. *I add a texture to the water with a No. 7 cool gray, over which I add mustard, dissolving some of the tones and creating a feeling of movement. I add brick beige to the sky and a little mustard on the wall. To coordinate the overall color effect, I add brick beige to all the dark areas.*

Watercolor

Watercolor holds a fascination for many people, I suppose because it is such a challenging medium. It can, as you have probably guessed, be very difficult to work with. Actually, to work properly with watercolor you must carefully plan your painting in advance. Unlike other mediums, you cannot just remove your mistakes with opaque paint. You must be able to put down the right colors and values the first time. Changing colors or overworking this medium can be a disaster. Watercolor should be very fresh and spontaneous.

Again, a thorough knowledge of the tools will help you become at ease with the medium. The key, of course, is to practice a great deal. Practice sketching and painting outdoors on-the-spot is a great way to become facile with watercolor. A good background in using designers colors will also help.

Many brands of watercolor are available, and one of the finest is Winsor & Newton. These colors, however, are quite expensive, so you may prefer to begin by using a watercolor set. Pelikan makes a nice 12 or 24 color set in a rust-proof box.

You should have a good selection of watercolor brushes, starting with Nos. 4, 5, and 7, but only use the finest red sables. You will also need a couple of inexpensive, wide sign-painter's brushes for wetting large areas or painting large, flat washes. Watercolor paper is available in rough, medium, or smooth surfaces and can be purchased in individual sheets or in the more convenient blocks, which are made up of many sheets. The Arches watercolor blocks from France are very fine papers to use. Here again, you will just have to experiment with the different papers and surfaces to find out your preference. Before you begin working, be sure to practice the exercises.

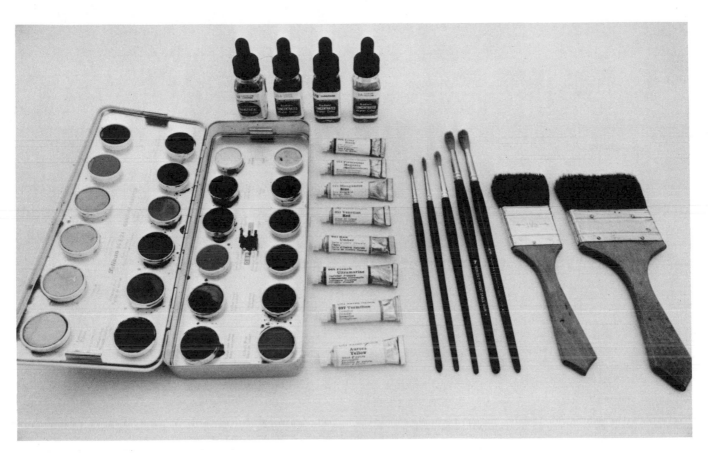

Here are some of the materials I use for watercolor sketching and painting. This watercolor box by Pelikan is very handy for outdoor work. Winsor & Newton watercolors are of the highest quality, but they are expensive. You could start out using a cheaper line, and as you develop in this medium, graduate to the more expensive line of paint. Dr. Martin's watercolors are very vibrant and are available in bottles, although they are really dyes and subject to fading. This line, however, is very popular and useful in the commercial art field where permanence is not a problem. Remember to use the highest quality red sable brushes. Cheaper brushes will not work well or last very long. The only cheaper brushes to use are the wide, soft-haired sign-painter's brushes, which are good for wetting or painting large areas.

Mix a tone of color and brush it on rough watercolor paper to see the type of line and texture that results.

Wet your paper with clear water first, then put a color tone over this. While this tone is still wet, brush on another color and study how the tones blend.

Try to paint a very even, flat color tone. For best results, wet the paper first with clear water, using a large sign-painter's brush. Then with a No. 6 or 8 brush, wash the color over the wet area.

Try to paint a tone that gradates from light to dark.

While this is still wet, paint over a color tone and add another color over this. Then dry the area with a blotter for an interesting effect.

After this has dried completely, paint a color tone over it, and wash over another flat tone.

Wet your paper with clear water, drop dabs of color onto the wet area, and study how the color spreads.

Follow the last exercise, but brush a little clear water over part of the tone while the tones are drying.

Paint a wash tone of color. As the tone dries, add dabs of color with your brush and study the reaction during the various drying stages.

Brush a wash of color over the watercolor paper without wetting the paper surface first. An interesting texture will result.

In this example, first wet the paper with clear water, then paint a tone, leaving a white area in the center. When the tone is almost dry, add some darker color tones–they will only blend in the damp areas.

On dry paper, paint some wash strokes. While these are still wet, paint over some of the strokes with another color. The colors will blend throughout the strokes.

Watercolor on Watercolor Paper, Portrait

Watercolor can be quite difficult for the beginner. This demonstration is a fairly simple type of watercolor and it does not take very long to execute. When you first begin using this medium, do small studies like this, gradually working up to more complicated subjects and larger paintings. You could start by painting from photographs—your own or from books or magazines. As you become more proficient in the medium, you can attempt to do some outdoor painting and sketching from nature. The important thing, of course, is to practice a great deal. You should also have a pretty good knowledge of basic drawing before attempting any painting.

When painting, I generally use a rather limited palette—a good idea for the beginning painter. Working with a few colors is a lot less confusing than 20 or more of them.

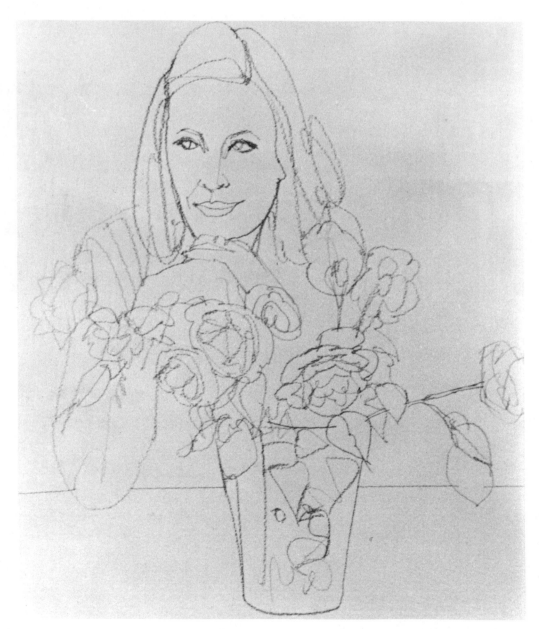

Step 1. *To begin, with an HB graphite pencil I do a sketch on the watercolor block. I use an Arches Special MBM watercolor block, made up of 25 sheets of 70 lb. paper. The surface of the paper is very rough, and works very well with the medium.*

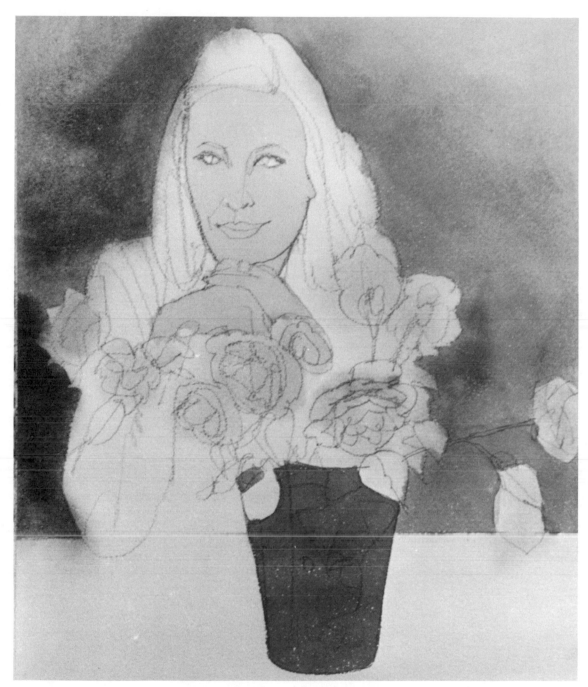

Step 2. As my palette, I use a large, enameled 12½" × 19" (31.7 × 48.3 cm) butcher's tray. These trays are usually available at artist supply stores and are perfect for this purpose. On the tray, I squeeze a little bit of these Winsor & Newton watercolors: rose madder, bright red, raw sienna, sepia, Winsor emerald, French ultramarine, cobalt blue, and ivory black.

I begin by mixing a tone with Winsor emerald and raw sienna. Before washing this color on, I first wet the paper with clear water, using a large 1½" (4 cm) sign-painter's brush. While the paper is still quite wet, I wash the color over. I add a shadow tone of sepia behind the figure. The flowers are painted in with rose madder and the flesh tones are a combination of bright red, rose madder, and raw sienna. At this point, I use an electric hair dryer to thoroughly dry the paper before continuing. As the color dries, I see that the background value is too light. A good thing to remember is that colors appear a little darker when wet. I go over the background again with the same color mixture of Winsor emerald and raw sienna, which darkens the value considerably. I now mix a tone with Winsor emerald and cobalt blue and I paint it on the vase.

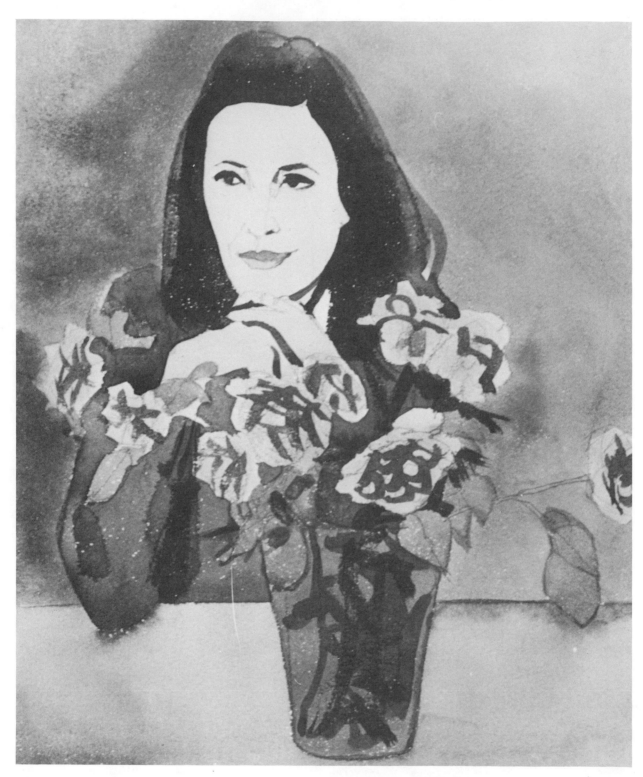

Step 3. French ultramarine and rose madder are mixed for the sweater. I use a much lighter value of this same color for the table. The color of the roses is warmed slightly with the bright red. I neutralize the table color with a brownish wash mixed from several colors on my palette. Black is mixed with cobalt blue and raw sienna, and this color is used for the hair as well as the eyes. A little of the bright red is added to black, cobalt blue, and raw sienna mixture, and I use this to paint in the details on the flowers and for the shadow tones on the hair.

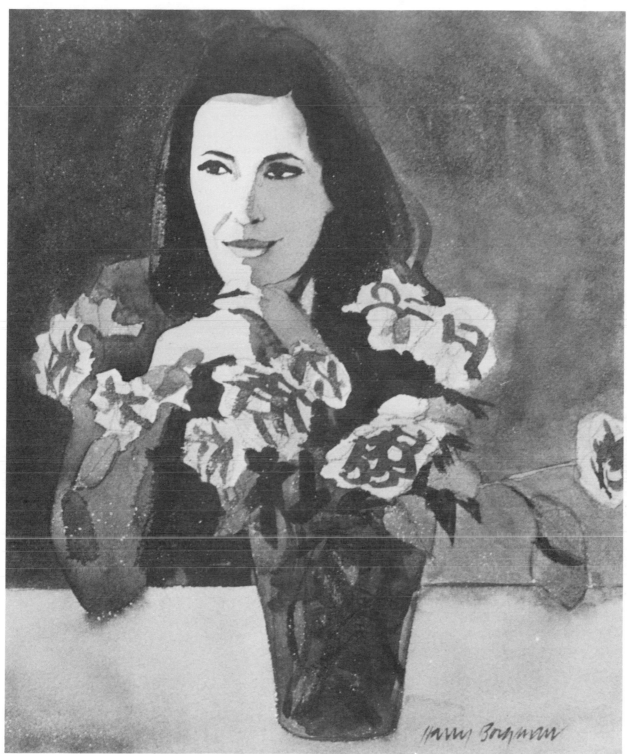

Jeanne, 10½" × 12¾" (26.7 × 32.4 cm)

Step 4. *I darken the shadow side of the face with a neutral tone mixed from bright red, French ultramarine, and black. I also darken the shadow side of the sweater, which makes the background appear too light. I paint a neutral tone over the background on one side of the figure. This accents the face nicely, so I decide to leave the other side of the background light.*

Notice that this painting has not been overworked–something to be very cautious about when using watercolor. Many of the elements in this painting, such as the flowers, have been indicated quite simply. It takes a great deal of practice to be able to render in a simple, direct manner.

Watercolor on Hot-Pressed Illustration Board

You do not always have to paint your subject matter in a realistic manner. There are other ways of doing paintings that are often more interesting than the literal method. One is the design approach, by which you think in terms of colors and shapes, the actual objects being secondary. In this demonstration I have used a smooth, hot-pressed illustration board—a surface not normally used with watercolor.

Many of my paintings are derived from small sketches done with markers or pencil. I keep drawings like this in a file for possible transformation later into larger studies or even paintings.

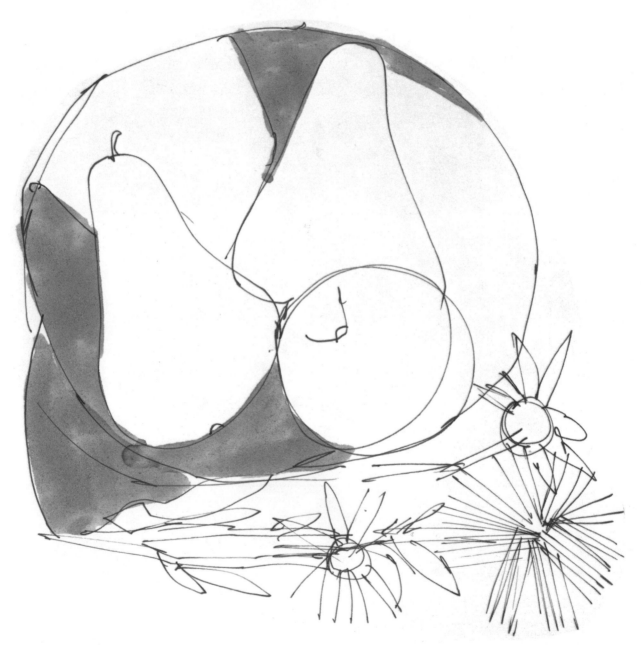

Step 1. Here is the original sketch that I used as a basis for this demonstration. It was drawn from life, on tracing paper with a black Pentel sign pen and Magic Marker gray. I liked the design quality of this sketch and felt it could be developed into an interesting painting.

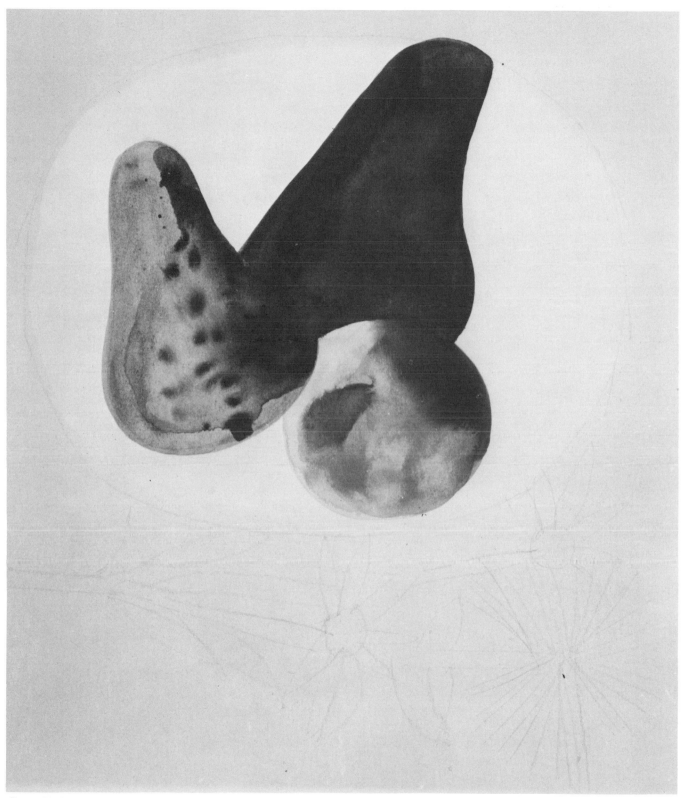

Step 2. *I make a pencil drawing on illustration board by enlarging the small sketch with a Beseler opaque projector. To start my rendering, I first wash a light mixture of French ultramarine, sepia, and aurora yellow. On the pear, I use a mixture of aurora yellow and Winsor green. The* *peach is painted with a mixture of vermilion, aurora yellow, and a little alizarin crimson. The avocado is painted with olive, Winsor green, and sepia. I allow some of the avocado color to run into the pear and peach.*

Step 3. With a mixture of olive, aurora yellow, and Winsor green, I paint in the stems of the flowers. A light yellow wash is painted on the flower itself. The dead leaves are painted with a mixture of alizarin crimson, sepia, and just a touch of French ultramarine.

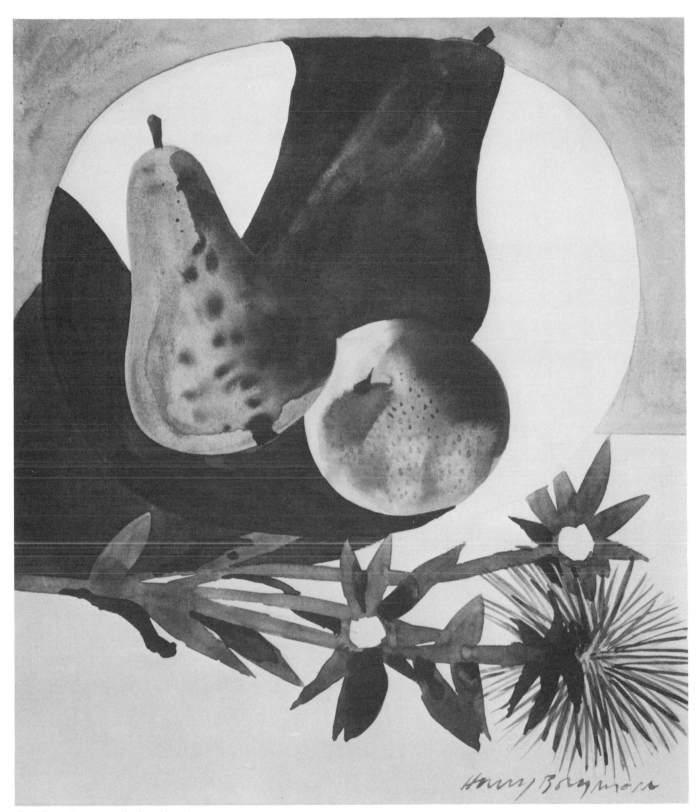

Still Life, 9½″ × 11″ (24.2 × 28 cm)

Step 4. For the shadows on the bowl, I use a mixture of sepia and French ultramarine. A neutral color is mixed from several colors on my palette, which is used for the shadow on the table. I lighten this neutral color a little and paint it over the top half of the background. I felt this addition added to the overall design quality of the painting.

Watercolor on Rough Watercolor Board

This type of painting is the most natural for the watercolor medium. It works best when colors are used very wet and allowed to run and blend together. When I want to control the washes, I always position the paper or watercolor block horizontally.

This painting was not painted on-the-spot, but was done in my studio, using one of my photographs for reference. Actually, the photograph was taken on a sunny day, but I thought it would be more interesting to make it a rainy scene.

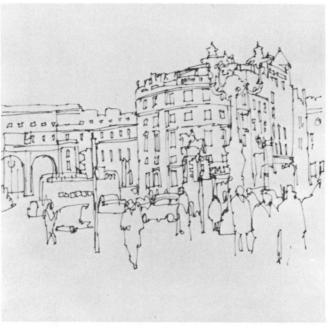

Step 1. *First, I draw the scene with an Eberhard Faber ultra fine Design Art Marker, which has waterproof ink, so I won't lose my drawing when I wash color over it. I use a sheet of Crescent watercolor board, rough surface No. 112.*

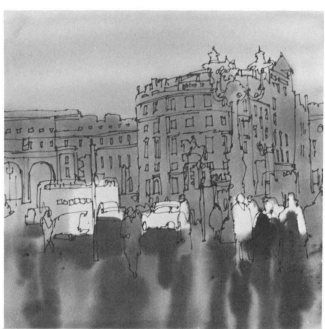

Step 2. *My palette consists of: sepia, Winsor blue, cobalt blue, olive green, raw umber, Venetian red, bright red, yellow ochre, and black. I begin painting by wetting the whole paper surface with clear water, using a large 1½" (4 cm) sign-painter's brush with soft hair. I mix up a neutral tone from sepia and cobalt blue, then add a little Winsor blue. These colors are mixed in a large butcher's tray as in Demonstration 14. Incidentally, I use this type of tray for most of my paintings, whether using watercolors, designer's colors, or acrylics. I brush the neutral mixture onto the areas that are the reflections. The washes spread nicely since the board is still damp. Next, I mix a little raw umber into this same color, making the tone a little warmer. This color is washed over the buildings in the background. I do this while the board is still wet so the washes will spread evenly. Now I completely dry the paper surface with an electric hair dryer. If you are painting outdoors on a hot, sunny day, you will find it difficult to keep the paper damp when you want it that way.*

Step 3. *A wash of Venetian red is painted over the background buildings. To warm up the color more, I add another wash of raw umber over this. I now rewet the street area with clear water and use this same wash of raw umber over it. I mixed a deep tone using Winsor blue and sepia, and paint in the shadows under the automobiles and people. This color really runs and spreads because of the dampened paper. I should remind you that when colors dry, they are a little lighter than when wet, so you should always mix tones a little darker than you think they should be.*

I now add bright red to one of the vehicles and let the color drip into the foreground, which gives the illusion of the wet street. With a mixture of raw umber and bright red, I wash over the background buildings, behind the arches. I add a little yellow ochre over this color to help give the effect of sunlight hitting the area in the background. At this stage, the sky seems a little light, so I add a tone mixed from raw umber and olive green to darken it. Before proceeding, I dry the painting with the electric hair dryer.

Step 4. *With a mixture of Winsor blue and black, I spot in some of the darker areas in the figures, statue, and street lamps. The brushes I have been using up to this point are a 1½″ (4 cm) sign-painter's brush to wet the paper surface, and a Winsor & Newton series 7 No. 8 for painting. For some of the finer details, I use a No. 5 brush. The dark accents really help perk up the painting and they also clarify many of the details. Next, I mix up a rather dark tone from Venetian red and Winsor blue. I use this mixture to paint in the lamp post in the foreground. A wash of yellow ochre is painted over some of the windows on the light side of the building behind the lamp post. I add some umbrellas with a dark mixture from my palette. A few subtle warm tones are added to the background using a mixture of bright red and yellow ochre.*

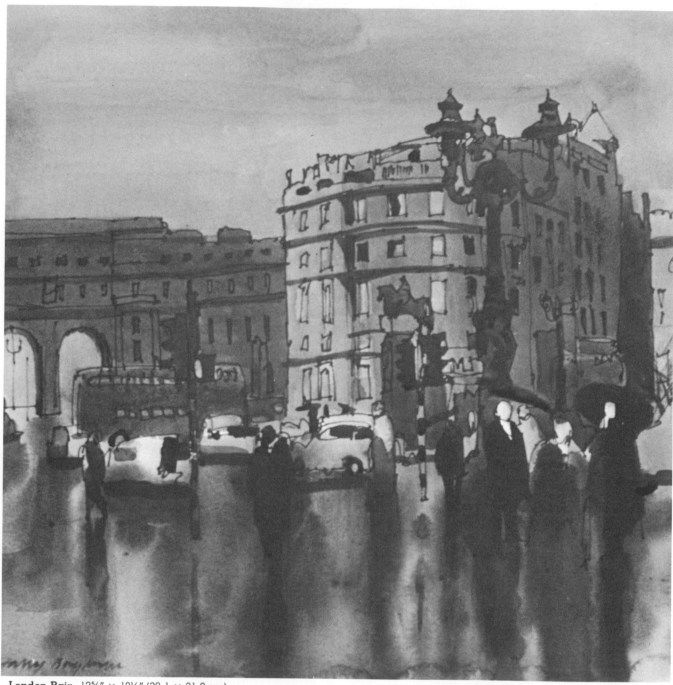

London Rain, 12⅝" × 12½" (32.1 × 31.8 cm)

Step 5. I decide to darken the background building, because it seems a little light. Now the other buildings appear too light, and I darken them with a wash of Venetian red and Winsor blue. I now carefully spot in some details such as auto tires, traffic lights, reflections in the windows, and more shadows. You must learn when to stop painting; if you overwork watercolors they will lose their spontaneous quality. It is sometimes difficult to know just when you should stop, but experience will certainly help you.

Designers Colors

Designers colors gouache is a different medium than watercolor but can be used like it, i.e., in a very wet manner. This medium can also be used in an opaque way, or you can add water to the opaque mixture and paint non-transparent washes. Designers colors are very popular and used extensively by commercial artists; they work exceptionally well with an airbrush.

The most popular brand is Winsor & Newton, because they are top quality paints. I have used them for many years and highly recommend them. They are available in a wide range of colors—about 80. This can certainly be confusing for the beginner, but you can get an introductory set consisting of ten colors. At first, however, you may just want to buy a tube of permanent white and ivory black. You can paint with these for a while, until you become acquainted with the medium.

Designers colors work very well on most paper surfaces: rough, cold-pressed, or hot-pressed. It is a matter of personal preference, though most illustrators favor hot-pressed boards. For your brushes, again I recommend that you use only the highest quality red sables such as Winsor & Newton series 7, or its equivalent. Practice painting by doing the exercise suggestions, and use these paints in thin washes as well as opaque. A good knowledge in using designers colors will give you a solid background for working in watercolor and acrylic paints.

The same brushes suggested for watercolor will work well with designers colors. The large, sign-painter's brushes are great for wetting the board surface or for painting large washes of color. Winsor & Newton designers colors are my favorite brand, but other good brands are available. There is a very good gouache made in France by Linel, a very popular brand.

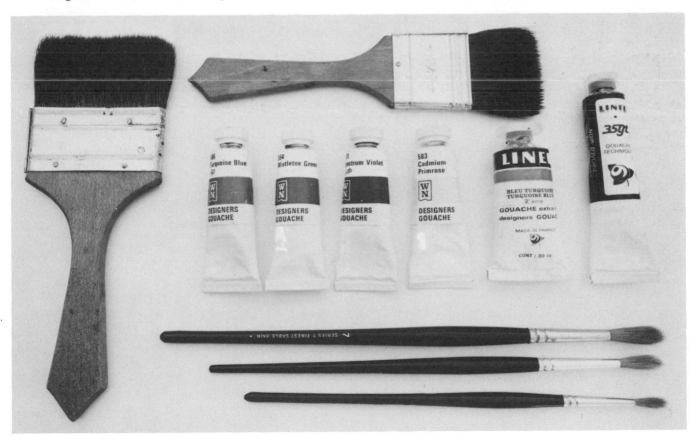

Try to paint a very flat, even wash tone. This can best be accomplished by first wetting the paper surface with a large brush and clear water. Then, while the paper is still damp, wash your color on.

Without wetting the paper first, paint various strokes to get the feel of how the paint works on the surface. Also, using a drier brush, see how many textures you can paint.

Paint a wash, and while this is still wet, paint other washes over. Study the way the paint spreads as the surface dries.

Mix a color with a little zinc white, then try to paint a very flat, opaque wash. Do this by previously wetting the paper, then try it without dampening the surface.

Paint an opaque wash. While still wet, paint wash strokes of a different color over to see how the paint spreads in comparison to thin, transparent washes.

Try to wash a tone that blends from very light to dark.

Paint an opaque wash, again using a color mixed with the zinc white. While this is still wet, drop a little clear water on and study how many different effects you can create.

Mix a thicker opaque color with the permanent white. Then try to paint a very flat tone. Your paint must be thoroughly mixed with the permanent white or you will get an uneven tone when the paint dries.

Paint a flat, even tone, using a mixture of color and permanent white. When dry, paint over tones of different colors. This will give you a good idea how opaque paint works over previously painted areas.

Mix a very thick paint mixture using color and the permanent white. Start painting tones over one another. Also try using the paint without much water; this should result in dry brush effects.

Using opaque paint, try to paint a blended tone ranging from light to dark.

Using color and the zinc white, paint an opaque tone. When this has dried, paint on some other tones of color using opaque washes.

Designers Colors on Rough Watercolor Board

Probably, more commercial illustration work has been done with designers colors than any other medium, no doubt because they are so versatile. They can be used thin, in washes (as watercolor is used), or very thick and opaque.

This demonstration was painted mostly using thin washes, done in a similar manner to watercolor. As I progressed I wanted to change a few areas, and I used opaque paint.

Step 1. First, I do a couple of rough compositional pencil sketches on layout paper. This type of sketch is the best way to establish your composition, and it can also help you judge where your contrasting tones will work best. Once my composition has been established, I do an accurate drawing on the illustration board, using a No. 3 sable brush with a wash of black. I begin painting by washing a tone of lemon yellow, brilliant green, and zinc white into the sky. To this mixture, I add a little cadmium orange and wash it over the sunlit background mountain. For the foreground shadow tone, I mix a combination of spectrum violet and ultramarine blue.

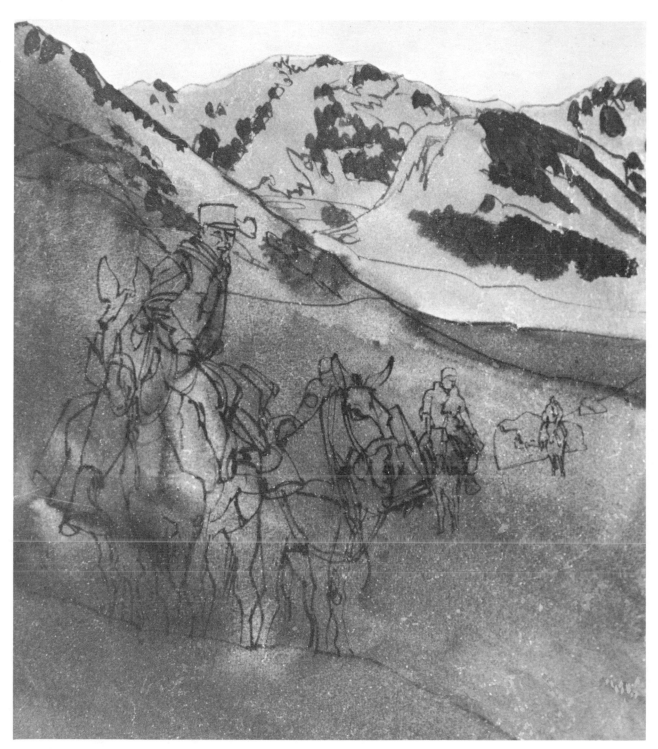

Step 2. *A mixture of permanent white and ultramarine blue is painted on the middle ground area. When permanent white is used, rather than zinc white, the paint mixture will be more opaque. The zinc white is much better for painting opaque washes. I brighten the sky considerably with a wash of turquoise blue and zinc white. The background mountain color is warmed up quite a bit with a wash of red,* orange, and zinc white. A mixture of ultramarine blue, black, and zinc white is washed onto the middle ground mountain. Spectrum violet, ultramarine blue, and zinc white are mixed and washed over the front of the mule to create an effect of reflected light. A few tones are added to the figures. I am trying to keep this painting quite loose and free, so I am mostly just indicating elements rather quickly.

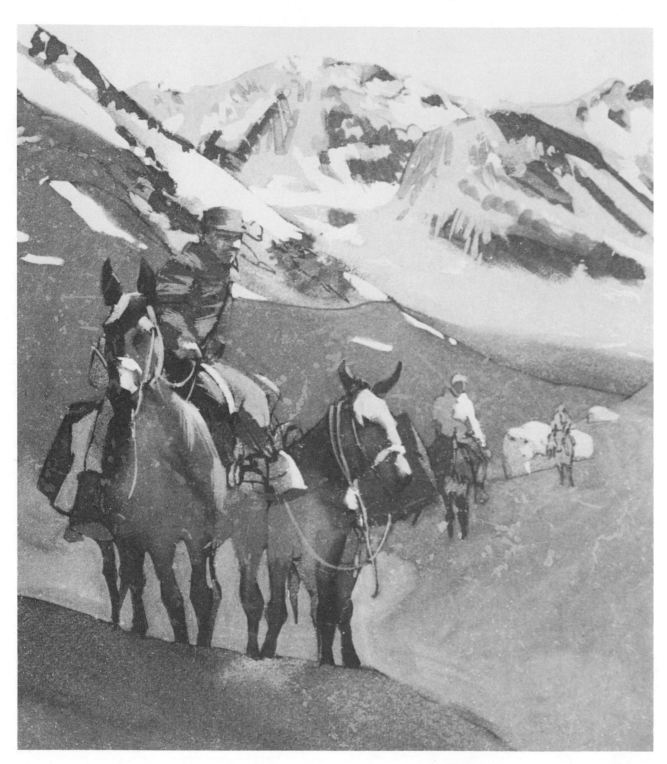

Step 3. *I darken the mountain area behind the riders and at the same time I warm up the color a bit by adding a little spectrum violet. With a mixture of cadmium orange, golden yellow, and zinc white, I wash over some of the sunlit snow. A slightly darker tone of this same color is washed on parts of the background mountain, highlighting the sunlit areas. I now decide to change the sky color. I paint in a mixture of sky blue, spectrum violet, and zinc white.*

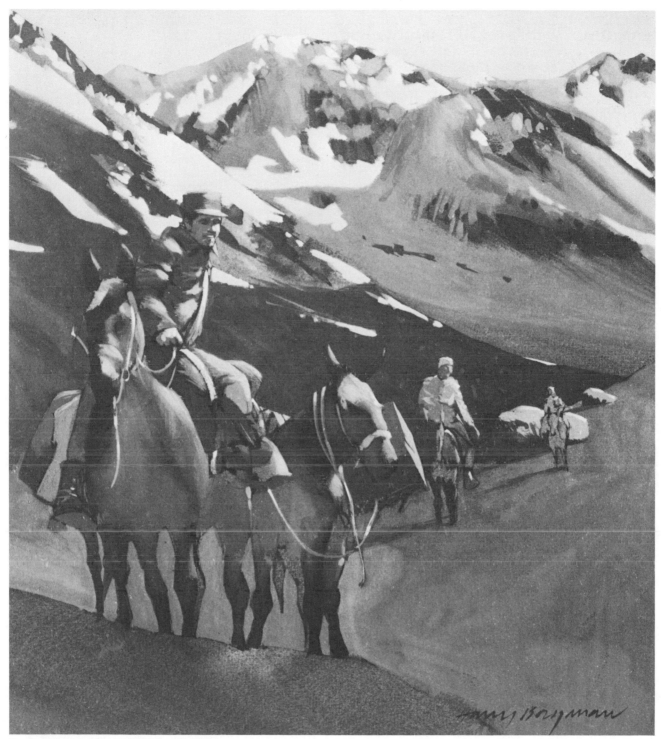

On Aconcaqua, 12″ × 14″ (30.5 × 35.6 cm)

Step 4. The sky does not seem right so I change it again by painting over it with a mixture of sky blue and permanent white. This time the paint is more opaque, because of the permanent white, and it covers the previous color satisfactorily. I mix a little more permanent white in this same color and use this mixture to paint the shadow tones on the snow. I brighten the sunlit mountain considerably with a wash of cadmium orange.

A light wash of cadmium orange, golden yellow, and permanent white is painted on the mountain to further give the illusion of sunlight. Some of the highlight areas in the background are softened by just going over them with a wet brush, blending the tones slightly. To finish, a few very bright white areas are spotted in the snow with permanent white.

Designers Colors on Illustration Board

This is an example of a more complex type of illustration, which was done for an advertising brochure. Frequently, an illustrator is asked to do preliminary sketches, which are shown to the client so that any changes can be discussed before the actual ad is presented. In this demon-stration, I will show you how the illustration developed from the art director's sketch right through to the final ad. This illustration is done using a combination of washes and opaque paint.

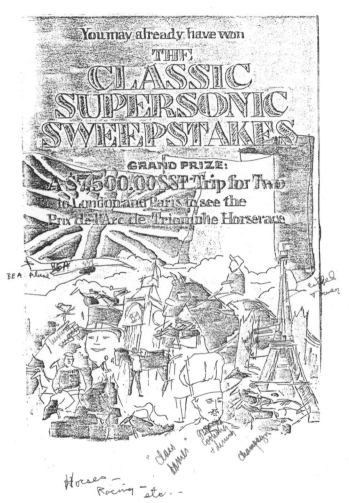

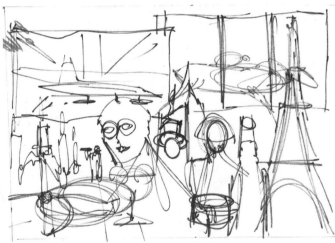

Step 1. *Here is one of my first rough sketches. I am trying to create an interesting composition using all the elements required by the client.*

Here is the layout that I received from my agent in New York. Actually, it was a copy of the original layout, but it gave me a good enough idea of what I was supposed to do. My representative also telephoned me so that we could discuss the assignment. I was asked to do a comprehensive sketch before going ahead with the finished art.

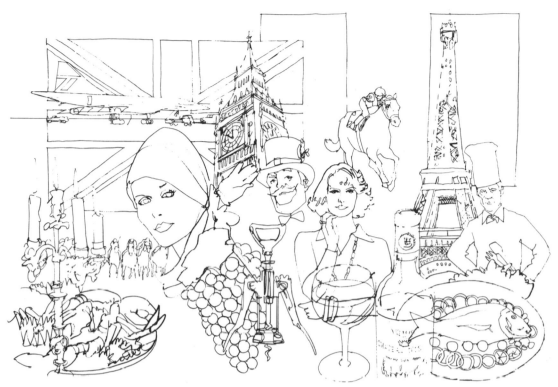

Step 2. *I develop the previous sketch into a pretty accurate pencil drawing. With this drawing, I make a couple of photostats, which I will use to paint the comprehensive sketch on. This is a very good method to use when painting com-prehensive sketches. If you make a mistake or ruin the sketch, you can just have another photostat made of your original pencil drawing and start over.*

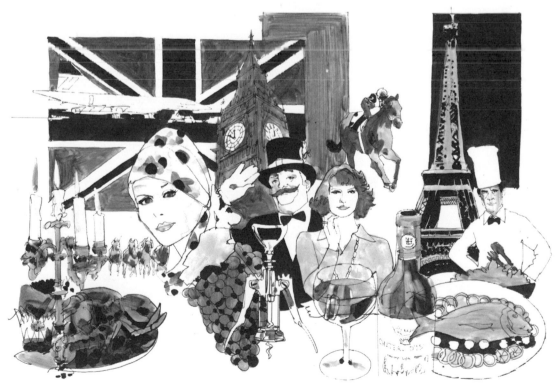

Step 3. *This is the comprehensive sketch that I sent to New York.*

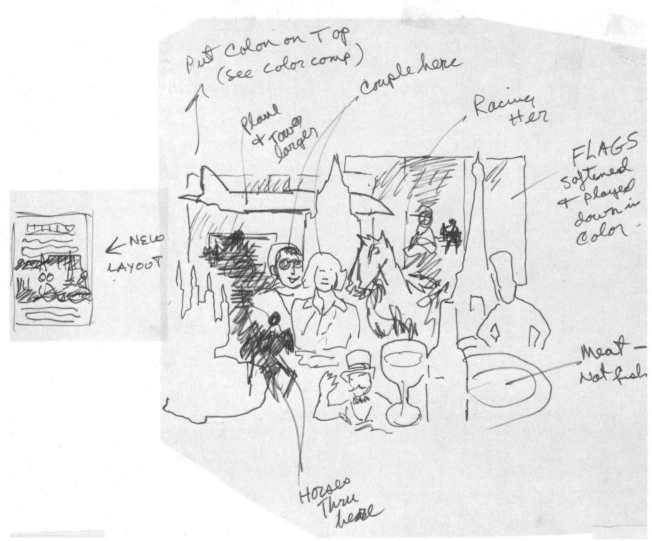

This is the tissue that came back with my sketch, showing all the corrections. A comprehensive layout like this helps to establish just what the client wants to show in the illustration. It also eliminates any problems that might come up after the illustration has been painted. You can see the changes the client wanted. The Concorde aircraft is much larger and in the air. Instead of just one woman, a couple is shown. More horses appear throughout the picture. Also, the whole illustration is done with an orange background color.

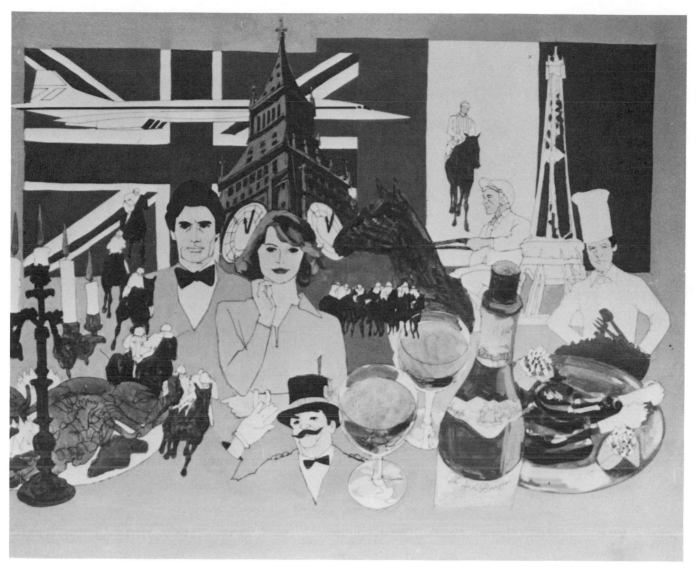

Step 4. *Using a 2H pencil, I make a basic draw-ing on a high-finished bristol board. When I am satisfied with my drawing, I begin the painting by putting in the orange background. I must render this area first because all the other colors in this illustration must relate to the orange color of the background. Next, I paint in the flags, since these colors are already established. I now work over the whole illustration, establishing all the color values first, just to cover up the white board. The details can be finished later.*

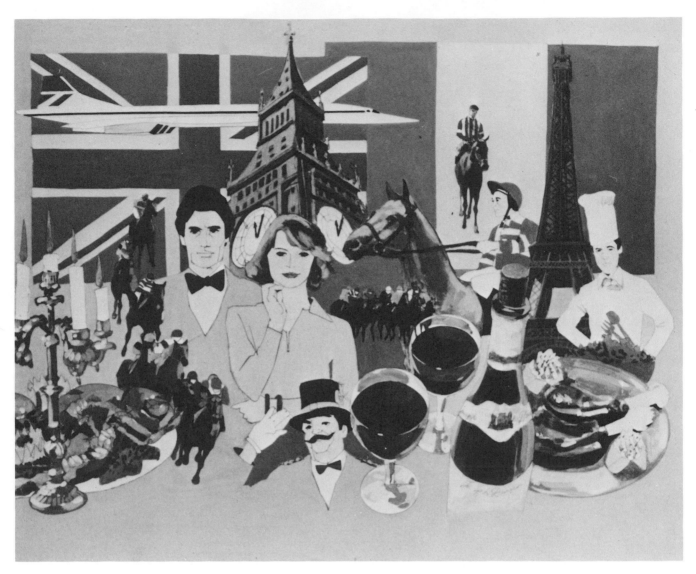

Step 5. *I keep working, changing many of the colors and values until they work nicely together. It is very difficult to paint against a color as strong as orange. The white areas on the flags are also too strong, overpowering the rest of the picture. I tone these down with a neutral gray color. I continue working over the whole illustration, finishing up by adding some highlights to the wine glasses and the candlestick.*

(Right)
Here is the final printed piece with the headline and additional copy. This was a rather difficult assignment, since I had a very tight deadline and had to do two other major illustrations as well as three minor ones in the rest of the brochure.

YOU MAY HAVE ALREADY WON...

THE CLASSIC SUPERSONIC SWEEPSTAKES

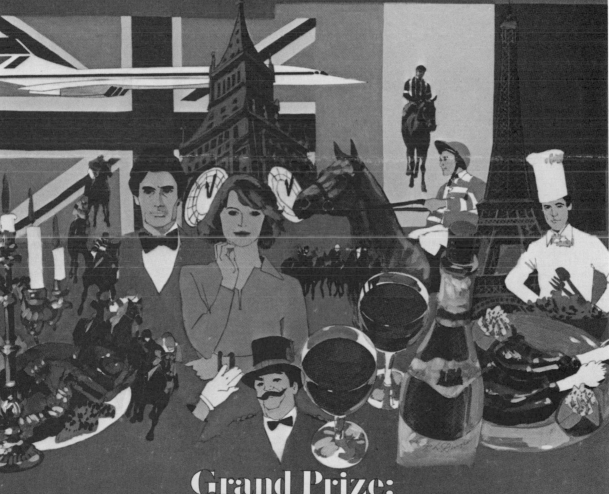

Grand Prize:
A $2,500.00 SST trip for two to see the great equestrian centers of England and France.

Advertising Brochure Illustration, 14½" × 10" (36.8 × 25.4 cm)

Acrylic

Acrylic polymer emulsion paint is quite different from the other painting mediums. One of the unique features about acrylics is that when they dry, they are waterproof and cannot be dissolved as the other paints can. Acrylics are a versatile medium that can be used in many different ways: very thin and wet (like watercolor), or very thick for impasto effects (like oil). The brand I prefer is the Permanent Pigments Liquitex colors.

If you have never painted before, I certainly would not recommend starting out with acrylics. They can be difficult getting used to, and you could become discouraged rather quickly, which could be a setback to your progress. Before starting to use acrylics, acquire a good knowledge of designers colors.

I am speaking from the experience of being a teacher, having seen over and over how difficult this medium can be for the beginner. Once you get used to working with acrylic, you will enjoy them immensely, as I do. A great deal can be done with this medium, and to give you a better scope of its range of techniques, I have added an extra demonstration in this section. Also, in the color section I have included eight additional examples that are quite different from one another.

Acrylic can not only be thinned with water, but can also be used with a polymer gloss or matt medium to achieve glazed effects. I often combine wash and opaque techniques when using acrylics, and they can also be successfully combined with other mediums, I frequently use them in combination with designers colors, especially on commercial assignments. In addition, a variety of textures are possible. I also use them to paint abstract color studies on canvas. So much can be done with these paints that it will take you quite a long time just to explore the basic possibilities. To master this wonderful medium, you will have to practice a great deal. Remember, however, you will be much better prepared to use acrylics if you have a good background in the other painting mediums.

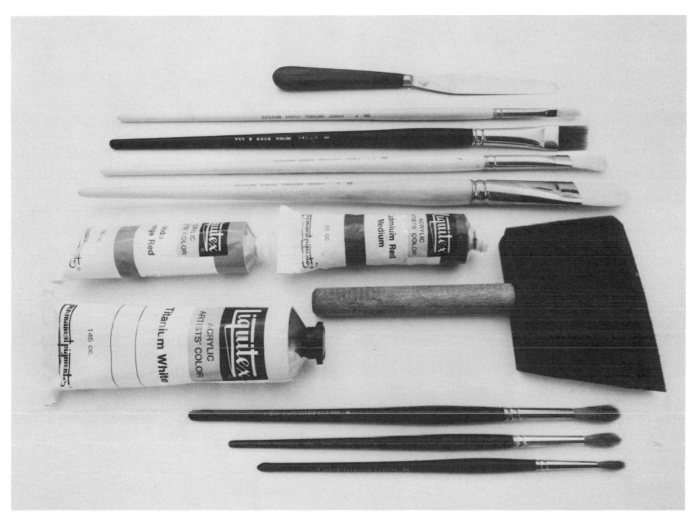

For acrylic painting, a wide variety of brushes are important. When working on illustration board, you will most likely use sable brushes. On canvas, bristle or nylon brushes will generally be a good choice. Palette knives are quite useful, and they are available in a variety of shapes and sizes. One tool that I find to be excellent is the Poly-brush (shown in the photo). It has a wedge-shaped plastic material attached to a wooden handle, and it works well for painting in large flat areas of color on canvas. I always use Permanent Pigments "Liquitex" brand acrylic paints, which I find to be of the highest quality.

Paint a color wash, and while it is still wet, paint other washes over using different colors.

Paint another wash; while it is still wet, paint over it using opaque paint of another color.

Paint some strokes and let them dry thoroughly. Now paint a color wash over them. The first strokes will not dissolve. Try this during various stages of drying, to see the different effects.

Mix a color with the titanium white and paint tones over one another, occasionally adding a little bit of the white.

Paint a flat, opaque tone and a color mixed with the titanium white. When dry, paint other opaque strokes over this. Your paint should be thick and dry.

Using opaque paint, try to paint an even, blended tone ranging from light to dark. Also try this with thin washes of acrylic paint, without mixing your color with the white.

Paint an opaque tone on canvas, and while still damp, brush on another color and blend it in. Use either bristle or nylon brushes for these exercises.

Paint another tone on canvas and let it dry. Then, using very thick paint, brush tones over, trying to achieve as many different textures as you can.

Over a flat color tone, paint another color by using only a palette knife.

Paint a flat color tone and let it dry. Mask out a shape, using Scotch Magic tape, then paint another color over the masked out area. Remove the tape and you should have a clean, sharp edge.

Paint a thin wash of color on the canvas. While this is still wet, paint another wash over this, using a different color.

Paint a flat, opaque tone on the canvas and let it dry. Then mix a few different color washes and paint these colors over the opaque paint.

Acrylic Paint on Canvas, Impressionist Technique

One weekend my wife, Jeanne, and I took a trip to Normandy to visit the World War II battlegrounds, specifically Omaha Beach. It was an interesting as well as a moving experience for us, and I decided to do a painting based on what we had seen. Omaha Beach, on the day we were there, was a strange sight. It was raining and some of the local residents were walking their horses along the beach. The images of the horses, figures, landing barges, and remains of the fortifications presented an almost surreal scene. I took a few 35mm color photographs to use as reference for my painting.

When I started the painting, I didn't quite know what I was going to do, or how I would handle this subject. I did not do any preliminary sketches, but just started drawing on the canvas, letting things happen as I went along. I was searching for a certain effect, which I couldn't quite pin down.

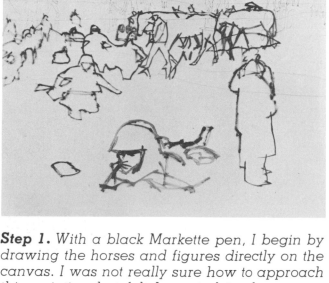

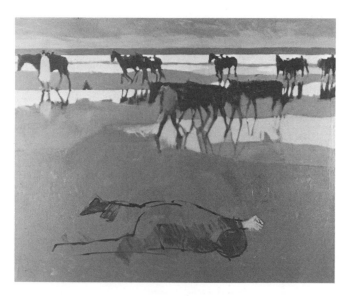

Step 1. *With a black Markette pen, I begin by drawing the horses and figures directly on the canvas. I was not really sure how to approach this painting but felt I wanted to show some images of soldiers on the beach. I draw the figures in with a No. 5 Winsor & Newton Lexington bristle brush and mars black acrylic paint. I now add more horses and figures to the middle ground, using the same bristle brush to draw with. In the foreground, I draw a couple with an umbrella. (There were quite a few people on the beach that day visiting the area.) I am not at all sure which direction the painting will take, and the confusion shows. I am not even sure, at this point, whether I will do a realistic or an abstract rendition of the scene. Often I start paintings this way, changing them completely from beginning concept to the finished piece.*

I use very few colors to paint this picture: cobalt and cerulean blue, yellow value 5, cadmium yellow, indo orange, raw umber, black, and white.

Step 2. *As a basic background tone, I mix up a blue-gray color mixture of cobalt blue, cerulean blue, black, and titanium white. This tone is brushed completely over the whole canvas using an ingenious device called a Poly-brush, which is a foam rubber wedge 4" (10.2 cm) wide, mounted on a wooden handle. It can hold a great deal of paint and can also be cleaned quite easily. To paint the background, I simply pour the paint, which I had mixed in a jar, directly onto the canvas; then, I spread the paint using the Poly-brush. If the paint is applied too thickly, the drawing underneath will be lost. To avoid this, I thin the paint with a little water, making it more transparent.*

I decide to take out the foreground figures of the soldiers as well as the couple with the umbrella. I mix some white with a little of the background color and use this to paint in the pools of water on the beach. With black paint, I indicate the horses and also add a few reflections. The color of the sea is a mixture of cerulean blue and white. I decide to add another soldier to the foreground; this is drawn with a No. 5 bristle brush and black paint.

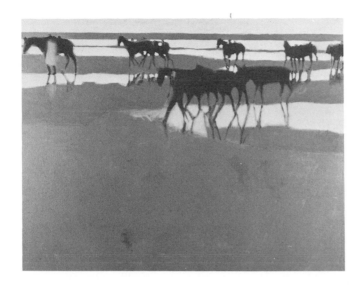

Step 3. The beach color seems a bit dull, so I add some warm patches mixed from indo orange red, cadmium yellow, raw umber, and white. I lighten up the pools of water and darken the horses a little. The sky and clouds are added using a mixture of cerulean blue, white, and a little black. I feel that the figure of the fallen soldier just does not work, so I paint him over using some of the background color I had saved.

Step 4. Rocks are characteristic of Normandy beaches, so I thought I would use them as a textural pattern in the foreground area. I mix up several different tones of color using cerulean, raw umber, and white. With these colors I paint in the rock pattern, and use black for the shadows under the rocks. On the horizon I add a slight bit of color, a mixture of yellow value 5 and cerulean blue with white, which seems to create a little more depth in the sky. I also add this same color to the pools reflecting the sky.

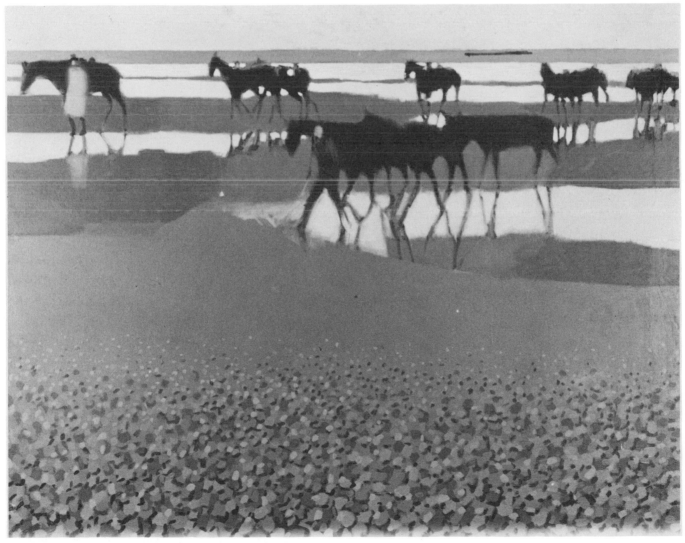

Omaha Beach, Normandy. 36" × 30" (91.4 ×76.2 cm)

Acrylic Paint on Canvas

This demonstration is an example of a non-objective painting, which is essentially a color and design study. You can learn a lot from this type of painting and can apply your knowledge to other techniques.

As in Demonstration 18, I had no idea how this painting would turn out when I began. In this case, I also had no notion of a basic design to start out with. Non-objective painting stems from your unconscious, a kind of coordination of your inner feelings and technical abilities—an interesting merger.

Step 1. *I start by mixing up a light neutral gray color using titanium white, mars black, cobalt blue, and raw umber, which is brushed over the whole canvas with the Poly-brush. I mix this color in a covered jar, so that it can be used later if necessary. In another jar, I now mix up some black with water. When it is about the consistency of heavy cream, I pour it directly over the canvas, making sure the background color has thoroughly dried. While the black paint is still wet, I use a piece of cardboard to spread the paint around the canvas surface. I let this dry before continuing.*

Step 2. *The dark color or perhaps the shape bothers me, so I completely wet the surface with clear water and use some old newspapers to blot off some of the black color. This is possible because the black had not thoroughly dried, only the surface had dried. When it is used thickly, it takes the acrylic paint a couple of hours to dry completely. Now that I have blotted some of the black off, the effect looks much better to me, especially since interesting textures resulted from this process. I now use some of the background color and paint a division across the black shapes, cutting it into four separate sections. I paint away some of the edges, masking them off first with Scotch Magic tape. I begin to draw some lines on the canvas with a Markette pen and a ruler. At this point I feel that I am off to an interesting start and have the beginnings of a good composition.*

Prospect, 36″ × 30″ (91.4 × 76.2 cm)

Step 3. *At this stage, I do not continue working on the painting. I feel that I ought to study it before going on. I decide to draw in a few more black lines with the marking pen. These lines are all drawn in a tight, mechanical way, using a ruler and French curves. The mechanical lines contrast nicely with the interesting textures and the free black shapes. I add some orange-colored shapes to the central part of the painting. Then, three black shapes are painted in and finally the lighter gray shape on the far left. To finish the painting, I paint in a small black triangle on the right and add the small white line above the middle area. I am quite satisfied with the painting and feel that it was a successful experiment.*

Acrylic Illustration on Canvas

This demonstration is an illustration assignment for Société Nouvelle de Prospective et Methodes, a French advertising agency that handles part of the French aerospace program. The subject of the illustration is Phebus, a new space satellite that will be launched by the French rocket Arian. This particular satellite is intended primarily for communications and television in Norway, Sweden, Finland, and Iceland.

For my first meeting with the client, I was asked to submit three sketches. After this meeting, I would then have a clear direction to go for the final painting. The client wanted the ad to clearly depict the countries this satellite was intended for by showing Scandinavian scenes. In this demonstration you will be able to follow all the various stages the illustration went through until the final piece.

Step 1. Here are the first three initial rough sketches that I submitted to the client. They are done on layout paper in Magic Markers, using a technical pen for the lines. The sketch showing the people interested them the most. They also liked the montage effect, where many unrelated things can be shown together. The shape of the illustration was now to be vertical rather than horizontal. We discussed which elements should be included and I was given the go-ahead, without having to submit another sketch.

Step 2. *Even though I was not required to resubmit a sketch before starting to paint, I still had to do a few for myself, to establish what I was going to do and how the composition would look. My first sketch seemed a little awkward so I* decided to change it by putting the satellite in the opposition direction and centering the earth in the top middle of the composition. This second sketch established my composition for the final painting.

Step 3. *Here is a much more accurate compositional sketch, which establishes what the final painting will look like. I did this sketch with black and gray Magic Markers on tracing paper.*

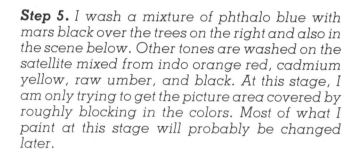

Step 4. *I begin the finished illustration by drawing directly on the canvas with a No. 4 sable brush and designers colors. Using the designers colors I can draw with finer detail than I would be able to do with acrylic paint. When finished, I spray the drawing with fixative so it will not dissolve when I paint over it.*

Step 5. *I wash a mixture of phthalo blue with mars black over the trees on the right and also in the scene below. Other tones are washed on the satellite mixed from indo orange red, cadmium yellow, raw umber, and black. At this stage, I am only trying to get the picture area covered by roughly blocking in the colors. Most of what I paint at this stage will probably be changed later.*

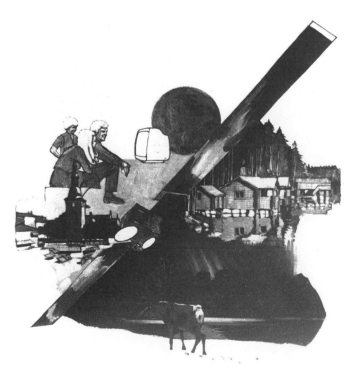

Step 6. *I begin to add more dark colors in the lower portion of the painting. For the color on the buildings I mix a little cadmium yellow medium and into orange red with white and a little black. With this same mixture, I also accent the water reflections. Highlights are added to the trees with a tone of white and raw umber. In the bottom scene, the client requested I show northern lights, or the aurora borealis, so I must keep the sky very dark in this area. I brush on a dark sky tone using a mixture of phthalo blue and mars black, and while it is still wet, I quickly brush in the northern lights using a white and yellow light hansa mixture. This effect works out just perfectly. I now paint in the caribou, using a warm underpainting of raw sienna, indo orange red, and black. Over this I paint the darker shadow tones, then add the brighter highlight effects last. A few hoofprints turn the white paper background into snow. I now start to work on the Oslo city scene and the figures.*

Aerospatiale/Nordsat Illustration, 15″ × 18″ (38 × 46 cm)

Step 7. Over the city scene I wash a rather thin coat of indo orange red, cadmium yellow, and raw sienna. The details of the buildings and surrounding area are finished up and the final shadow tones are painted in. The final step is to paint white paint around the outer edge of the painting, over the whole background. The canvas is not a pure white, so I felt it would look a lot better painted over.

Acrylic on Canvas, Figure Study

In this demonstration I use a more traditional painting method, one that is quite similar to the oil techniques. This figure study is done in a realistic style, using few colors. If I had continued working on this painting, I could have developed it into a very photographic rendition, but I chose not to carry it that far.

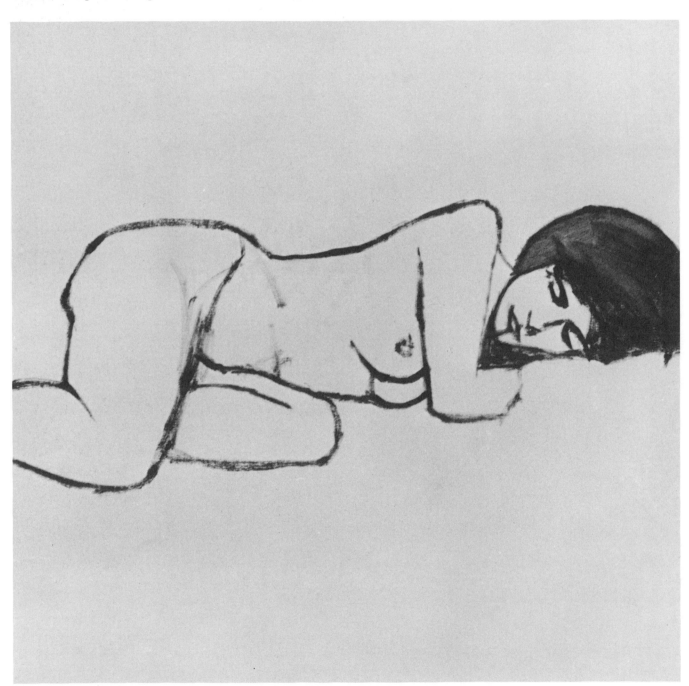

Step 1. *First, I draw directly on the canvas with a bristle brush, using mars black. I let this drawing dry thoroughly before painting in my background color so the image will not be washed away.*

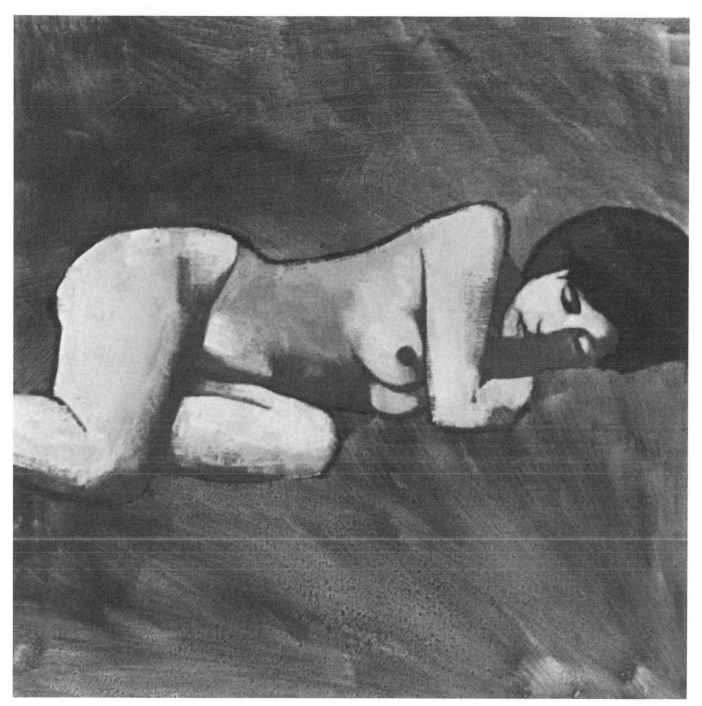

Step 2. *For this painting I use: burnt umber, burnt sienna, red oxide, cadmium red pale, cadmium yellow, hansa yellow light, red purple value 5, blue value 5, black, and titanium white. I mix burnt sienna and burnt umber, then wash this tone over the whole canvas. This establishes a neutral tone for me to paint against. For a flesh tone, I mix burnt sienna, red purple, and white, which is brushed on the figure. For the shadow tone on the figure, I use a mixture of black, red oxide, and a little white. I work over the whole figure, painting in the eyes and hair, modeling the various shapes, and establishing the highlight areas. I warm up the flesh tone with a mixture of cadmium red pale, cadmium yellow, and white, which I use mainly on the highlight areas.*

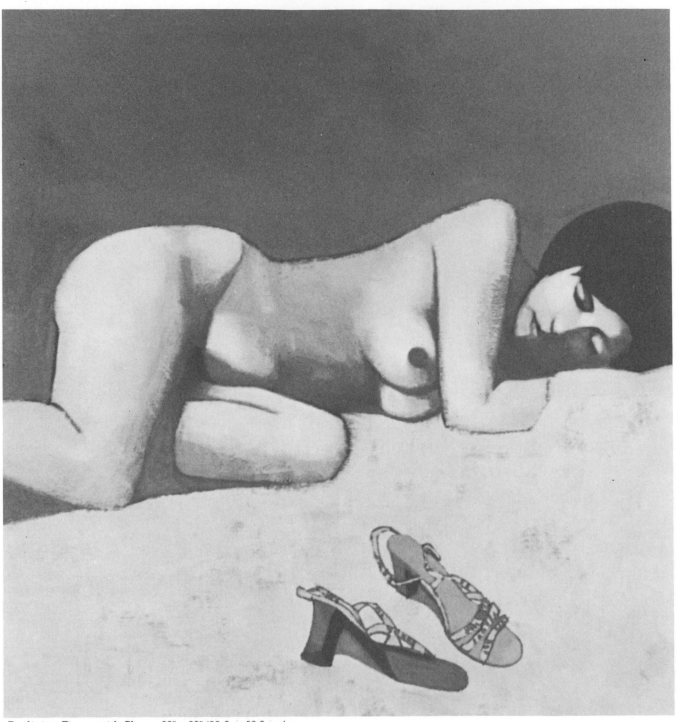

Reclining Figure with Shoes, 20" ×20" (50.8 × 50.8 cm)

Step 3. *I mix blue value 5 with black and paint this tone on the background. A light tone mixed from burnt sienna, burnt umber, black, and white is painted on the foreground area. At this point I feel that the painting needs another element for interest, perhaps in the foreground. I decide to put a pair of shoes in. I do a few sketches on tracing paper first, so I can place the shoes in the right spot compositionally. The shoes are then painted in using red oxide, cadmium yellow; and mars black, and I warm up the shadow tones on the figure slightly, using cadmium red pale, finishing the painting.*

Mixed Media

I have mentioned throughout this book that many painting or drawing mediums can be mixed or combined. Actually, anything goes; the only limiting factor is your own imagination. You can literally go wild mixing watercolor, inks, dyes, pencils, and markers, using them together in any combination. When I mix mediums, rather than doing it randomly, I try to use each particular medium according to its best advantage. If say, I want a bright, translucent wash tone, I would either use watercolor or dyes. For an opaque paint that is water-resistant, I would use acrylics. If I want to draw a line that will dissolve a bit when water is washed over it, I would use a Pentel Sign pen.

Obviously, it is important to have a thorough knowledge of all the mediums, especially if you want to use them in combination. In addition, knowing your tools will help you utilize these combinations. It is up to you to practice and experiment with all the available drawing and painting mediums. It probably will take you a long time to explore all the possibilities in mixed media, and then you may only be scratching the surface. I offer a few practice suggestions that will help you get started, from there you are on your own.

For these exercises use a cold-pressed surface. Paint an opaque wash tone, and paint another tone on in a contrasting color. When the paint dries, draw over the area with Prismacolor pencils.

On your board draw with a black Pentel Sign pen. Using a brush with clear water, wash over the strokes, dissolving them.

Draw some tones and lines with a Stabilo All pencil. Paint a designers colors wash over the pencil lines, as well as clear water. Study how the Stabilo pencil lines and tones dissolve.

Experiment with paint washes and the various types of colored pencils available. Certain brands of pencils such as Mongol and Prismalo are water-soluble and yield very interesting effects.

Draw some strokes and textures with different water-soluble marking pens such as Pentel, Pilot, and Dri Mark. Wash different color dyes over these lines to see the various effects possible.

Wash some tones of dyes and paint. While this is still wet, drop a little bit of waterproof India ink on the surface. Then, try the same thing using the water-soluble ink. Study how these tones spread on the paint areas.

Paint some color tones, mixing your washes with water-soluble ink. Use a blotter to dry certain areas; interesting textures will result.

Try painting on canvas with watercolor, dyes, designers colors, and colored pencils. Experiment with washes as well as opaque paint. Markers can also be used on this surface.

Designers Colors and Colored Pencils

Paint is not the only medium that works will in combination with other mediums—colored pencils and marking pens can be used quite successfully with dyes and paint. The pencils used in this demonstration are Prismacolor by Eagle. They have a very extensive range of 60 colors. They are not water-soluble, but there are other brands available that will dissolve when water is washed over the tones. Complete illustrations can be done using the water-soluble pencils, without using any paint at all.

This painting is based on several photographs that I took at a Michigan rodeo. I always carry my camera with me, especially when attending events such as rodeos or auto races. Much of the material I photograph can be reviewed later for painting or illustration possibilities.

Step 1. *To begin, I do my basic drawing with a gray Eagle Prismacolor pencil on cold-pressed illustration board. As reference, I am using several photographs taken at a rodeo. I project the photographs with a Beseler opaque projector, and draw the image directly on the board in the exact size and position I want. The opaque projector is a valuable tool for the illustrator since it can save a great deal of time. My painting will be a combination of several photographs. Since I have photos of riders in various positions, I decide to show a rider in different sequences. Also, I will accent the rider by leaving a white rectangle around him, and with Scotch Magic tape I mask out the rectangular shape. This way, no color will go on this area when I wash in the background. This tape is excellent for masking areas on paintings and will leave a very clean, sharp edge. For a background color, I mix a wash of these designers colors: yellow ochre, raw sienna, and linden green. I wash this over the whole background and when it is completely dry, I remove the tape. I now paint the same background color over the horse and rider in the white shape.*

Step 2. *With a black Prismacolor pencil, I draw in the dark tones on the horses and riders. I do this by using strokes, creating the tones with lines, to add an interesting texture to the drawing. Then using my designers colors, I wash a mixture of zinc white, raw sienna, and linden green on the lighter parts of the horse. A very light tone of linden green mixed with zinc white is washed over the rider's shirt. Sky blue is mixed with the raw sienna and painted on the rider's pants. I am trying to develop this central area first before going on to the other parts of the painting.*

Step 3. With the designers colors, I mix a little zinc white to the background color, which is painted on the fence outside the white rectangle. I begin to render the foreground figures by washing a green-gray tone on the shirt and a blue green on the pants. Then, taking a Prismacolor pencil, I draw a tone of light flesh on the sunlit areas of the shirts. To warm up the shadows on the pants, I use a red pencil. I add a few highlights on the figures with the permanent white paint.

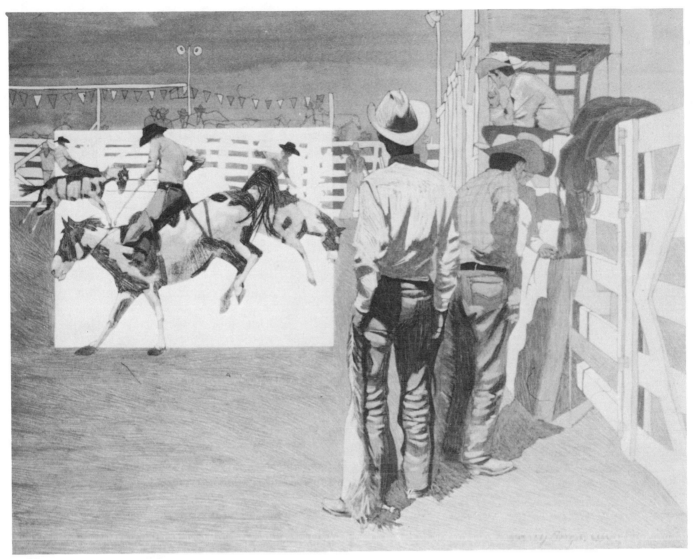

Hillsdale Rodeo, 18⅜" × 15⅜" (46.7 × 39.1 cm)

Step 4. Over the ground area I use a vermilion pencil, drawing strokes in one direction to create a texture as well as a tone. I go over this with a burnt ochre pencil, darkening the value. I decide to add a burnt sienna shadow from the figures since they seem to be floating in the air.

Canary yellow pencil is used on the sunlit areas of the horses as well as the rider's shirt. To the horses I add a tone of orange pencil, which helps to give the impression of reflected light. This also seems a better way to tie the horses into the overall picture.

Ink Line and Designers Colors

This demonstration shows a very interesting technique that enables some line drawings to be converted to full color art. This process, of course, is primarily used in the commercial art field, but it is a method that you may find useful. The original piece for this demonstration is actually an ink drawing from my book *Drawing in Ink*, also published by Watson-Guptill, where you can find the step-by-step demonstration. The first step in converting a line drawing for use as a full color painting is to have a film positive

photographed from the original drawing. The particular photo lab that I dealt with was also able to furnish me with a very light gray image of the same drawing on illustration board. This process is apparently rather specialized and may not be available in your area. Even if it is not possible to have the gray image photographically printed on your illustration board, you can make a tracing of your line drawing and transfer it to your illustration board using a graphite tracing sheet.

Step 1. *This illustration board has the image of my line drawing reproduced photographically. The film positive of the ink line drawing has been lifted so you can see the image on the board. Another way to reproduce an image on the board is to make a tracing of the ink drawing from your film positive, then transfer this to the illustration board by tracing it through a graphite tracing sheet. The image is needed on the illustration board because you must have an accurate outline of your drawing so that you can paint within the areas you want color.*

(Right column)
Step 2. *I use Scotch Magic tape to mask out areas where I do not want background color, such as the explosion and the aircraft insignias, trimming the tape to fit with an X-acto knife. I wash clear water over the whole paper surface. While this is still damp, I add colors, brushing them in with a 1½" (4 cm) sign-painter's brush.*

After the washes are painted in, I dry them with a hair dryer, then carefully remove the tape from the covered areas with an X-acto knife.

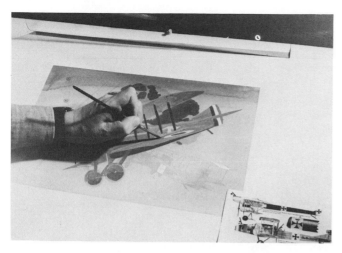

Step 3. *I continue painting over the whole picture using references when adding the details to the aircraft.*

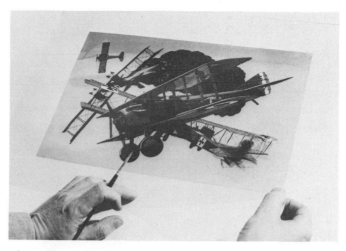

As I work, I must frequently lower the film positive over the painted area to see if the color values and tones are correct. The colors appear different when you put the black line drawing on the film positive over it.

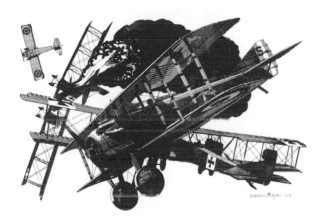

Here is the actual ink line drawing that was used for the final full color illustration. This drawing is from my book, Drawing in Ink, *where you will find the step-by-step demonstration.*

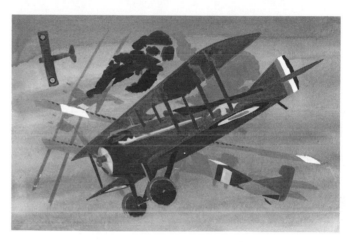

This is the underpainting, which was done on the illustration board, without the line drawing over it.

French Spad in Action, 18″ × 12″ (45.7 × 30.5 cm)

Here is the completed illustration with the film positive
in position over the color rendering. This is a very
useful technique in the commercial art business.

Markers, Dyes, and Designers Colors on Cold-Pressed Illustration Board

In this demonstration I combine marking pens, dyes, and designers colors on illustration board. I often mix mediums, especially with certain subjects when one medium just too limiting. Many of the interesting effects in this illustration were achieved by dissolving Dri Mark pen lines with clear water. These pens have a very fine point and are available in several colors. The basic drawing for this illustration was done with the brown, blue, red, and black Dri Mark pens. I also use Dr. Martin's dyes and designers colors. For this demonstration, I used a cold-pressed board surface, but a smooth surface would have worked equally well.

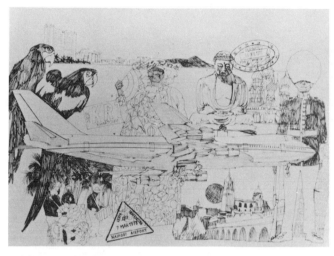

Step 1. *I start by first drawing with a black Dri Mark pen directly on a sheet of Lewis illustration board. For my basic drawing, I use four different colors, black, brown, blue, and red, just for an unusual effect. The Dri Mark pens have a very fine point and are excellent to draw with. I draw the aircraft by projecting a photograph of it onto the illustration board with a Beseler opaque projector. I add the other objects, composing the picture as I go along. When my basic drawing is complete, I begin to draw a series of lines over certain areas that will be washed over with clear water.*

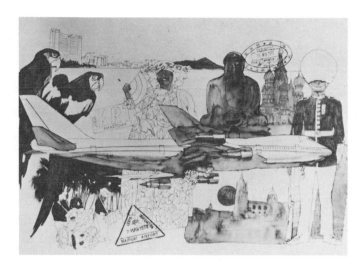

Step 2. *With a Winsor & Newton No. 5 brush I dissolve some of the marker lines using clear water. This creates a fairly flat tone in these areas. The blue color on the aircraft fuses nicely with the black creating a most interesting effect. At this point I am not worried about how the colors go on, since I can always change any areas later with opaque paint.*

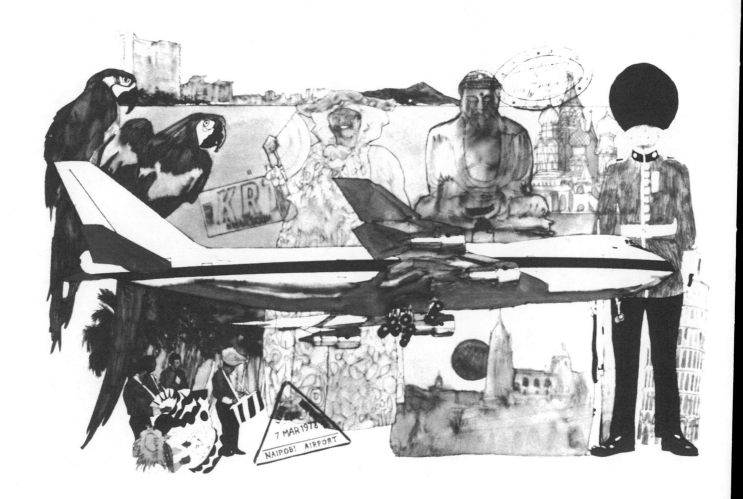

Step 3. Using Dr. Martin's dyes, I add yellow to the parrot and to the lady's hat and shawl. These dyes are extremely bright and also dry quite flat and even. I use ivory black designers colors for the royal guard's hat and pants. I wash orange, blue, green, and red dyes over various areas of the illustration and add a few black accents here and there. The illustration seems to be shaping up very well at this point. Using designers colors, I mix up a tone of sky blue, black, and zinc white, which is painted on the underside of the aircraft for a shadow tone.

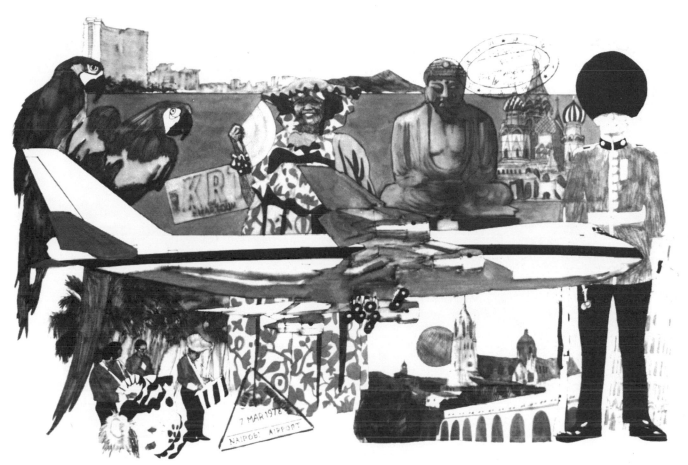

Travel Montage, 15½" × 10⅜" (39.4 × 26.3 cm)

Step 4. *I wash a red dye on the Surinam lady's dress pattern and begin to build up the forms of the Buddha with opaque paint. I am trying to relate all the colors in the picture so everything is in harmony. With a brown Dri Mark pen I re-* *draw the face of the woman, which was lost when I washed the water over. I finish up all the details in her dress pattern using cadmium red pale designers colors.*

Part 3
Color
Section

In this part of the book you will find full-color reproductions of Demonstrations 10 through 24. In addition, there are several other examples of paintings done in various mediums. I added more acrylic illustrations since this particular medium has almost endless possibilities, and I chose these examples to demonstrate the tremendous variety that you can produce with acrylic. Reproduced are some of my latest commercial illustration assignments, paintings I do for pleasure as well as experiment. Included also are a few watercolor sketches done on-the-spot while traveling. Study all of these paintings very carefully and on the demonstration examples, refer back to the pages that show the exact steps, so that you can clearly see how each painting was done.

The case history I use in this section (pages 128−131) turned out to be particularly interesting because of the many client changes involved. This example is especially revealing, since it demonstrates some of the actual conditions an illustrator must work under at certain times. Of course, not every assignment turns out to be this complicated, but it does happen occasionally. A requirement of the illustration was to depict many of the company's functions, and this factor added to the problem, because some areas needed more emphasis than others.

Ink, Dyes, and Watercolor on Illustration Board, Composite Subject

This illustration is essentially a line drawing filled in with color. Using India ink diluted with a little water, to soften the black, I inked over the lines of my initial pencil drawing. Since the subject is complex and has many elements, the color is painted with clean, bright washes of Dr. Martin's dyes and Winsor & Newton watercolor to keep the overall feeling as fresh and uncluttered as possible. Opaque designers colors tone down areas where the color would otherwise be too bright and overpowering.

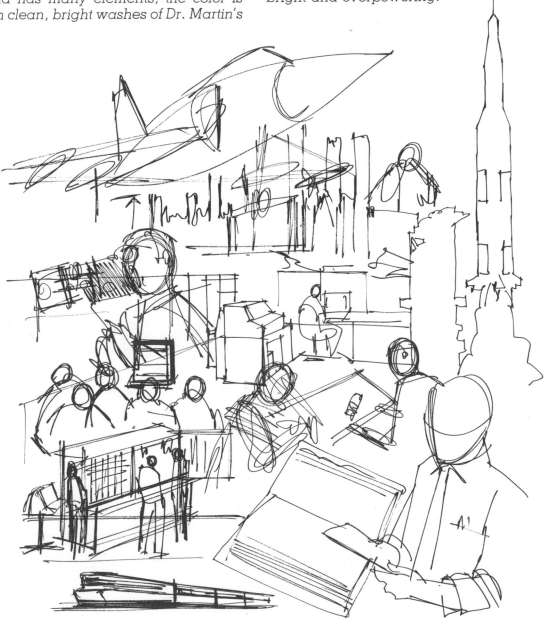

Here is one of the many rough compositional sketches done for the Sogitec ad. This kind of a sketch helps you to establish your composition and judge the sizes of the various elements that must be depicted. I usually do these drawings on layout or tracing paper with either a graphite pencil or a marker pen. These sketches can be improved or changed by laying another sheet of transparent layout paper over the first sketch, making a new drawing with any necessary changes. This kind of sketch can also be used as an underlay when doing a comprehensive layout for presentation to the client. The following examples show the color sketches and comprehensive layout done for this ad.

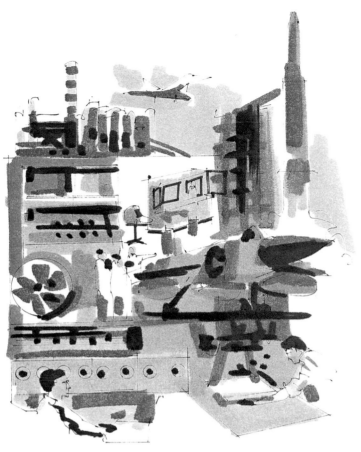

Sogitec.
Du traitement de l'information industrielle
à la formation audiovisuelle.

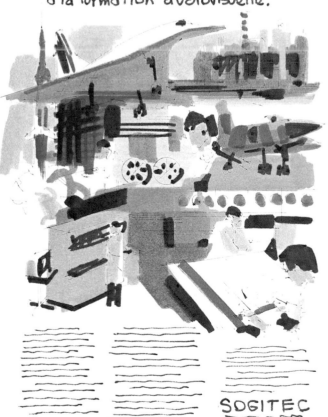

SOGITEC

These are the first color rough layouts that were done to establish the general direction of the ad. Although these sketches are quite loose and roughly done, they nevertheless give a very good impression of what the final ad will look like and all the elements are clearly delineated. These sketches were rendered on layout paper using Magic Markers, and a technical pen was used for the fine outlines. On one example, the headline and the body copy has been indicated to give the client an even better idea of what the final ad will look like.

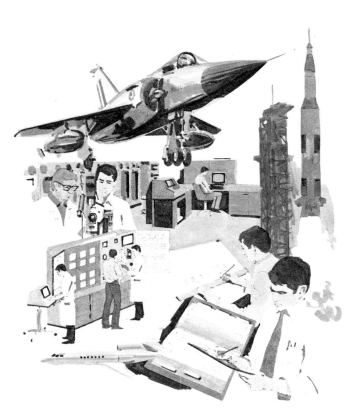 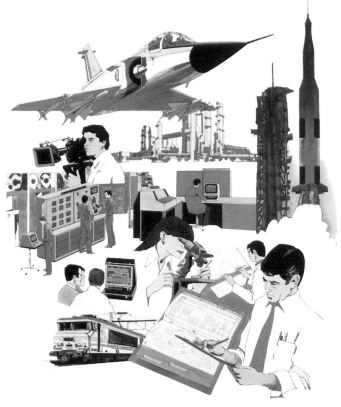

This is the comprehensive layout done with a technical pen and Magic Markers on a high quality layout paper. It was rendered exactly the same size as the finished art was to be painted, 15" × 17½" (38 × 44.5 cm). Most commercial illustrations are painted in a larger size than reproduction size since it is easier to work on a larger scale. This sketch was done to show the client exactly what the final art would look like. The client had a few changes that will be apparent in the next example.

This is the finished painting with all the changes that the client requested. The illustration was done by first doing a basic drawing in graphite pencil, then I went over this drawing with diluted India ink. The color tones were added with washes of watercolor and dyes, and in some areas opaque designers colors were used.

(Right)
Here is the finished printed ad, complete with headline, body copy, and company logo. The client insisted that I change the position of the cameraman and the creative director wanted some color added behind the refinery. Compare the final ad with the first rough sketches. There really is quite a similarity, the roughs do capture the general feeling of the finished ad.

Traitement de l'information technique. Si vous ne connaissez que cet aspect de Sogitec, vous ne nous connaissez pas vraiment !

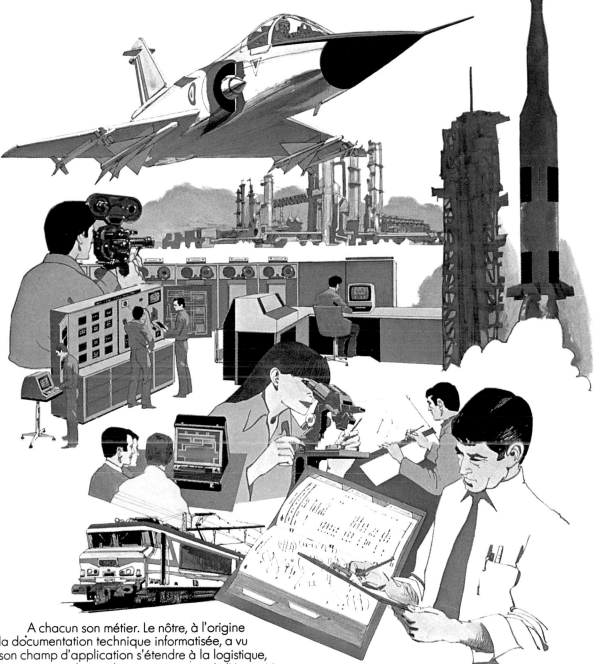

A chacun son métier. Le nôtre, à l'origine la documentation technique informatisée, a vu son champ d'application s'étendre à la logistique, l'instruction et la simulation ; au service de l'Après-Vente.

Notre position internationale nous permet d'offrir les mêmes services en France, aux U.S.A., en Allemagne ou en Amérique Latine.

Si depuis 15 ans, nous avons aussi bien réussi, c'est pour avoir apporté des prestations de grande qualité à des entreprises en expansion qui ont pu ainsi se consacrer exclusivement à ce qu'elles savent bien faire.

Peut-être êtes-vous aussi l'une de ces entreprises ? Alors contactez-nous.

SOGITEC INDUSTRIES

27, rue de Vanves – 92100 Boulogne (France) Tél. : 609.91.01

M.A.O. Akjaly, Stollerman.

Markers on Tracing Paper, Portrait

Tracing paper is a very compatible surface for marker techniques. The marker dyes do not quite soak into the paper but rather lay on top, allowing you to rework areas. You can easily cut back into darker tones by overpainting with a lighter marker. All the highlights on the face, the pinafore, as well as the flowers on the dress, are produced this way. Painting with markers on a glossy-coated paper, the kind used in printing, can give similar results.

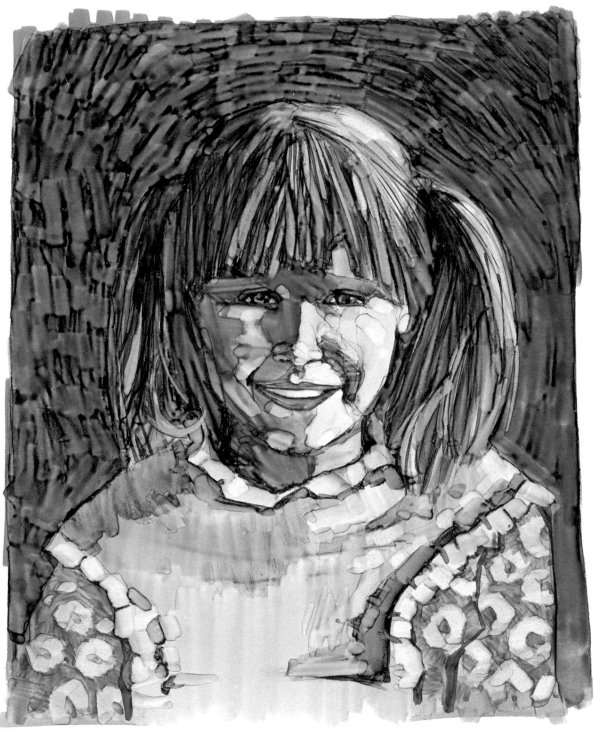

Stephani, 10″ × 12″ (25.4 × 30.5 cm)

Markers on Tracing Paper, Mechanical Subject

This is the same technique as Demonstration 10, page 132, but the subject is mechanical. All the highlight areas are produced by overpainting the darker tones with lighter markers. To add to the feeling of motion, I use a cloth dampened with Bestine and wipe it across the crowd area.

Bestine is a rubber cement thinner that also dissolves marker inks. To get the feeling of smoke and dust in the background, I first go over the area with a light suntan marker and wipe the color away with a cloth, while it is still wet.

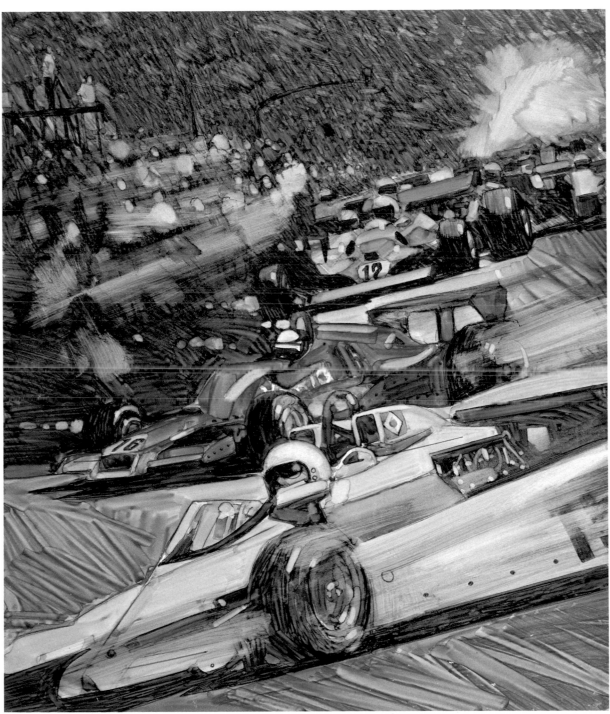

Grand Prix, 14″ × 16½″ (35.6 × 41.9 cm)

Markers on Bristol Board

This painting is done on a regular surface Strathmore bristol, a board with a slight surface texture. A high-finished, smooth-surface bristol also works very well for marker painting. Compare this demonstration with the previous marker paintings and you will see that the effect here is much softer than that achieved on tracing paper. Markers work nicely on most types of paper surfaces and board. Experiment with different surfaces so you will become familiar with the many effects that are possible.

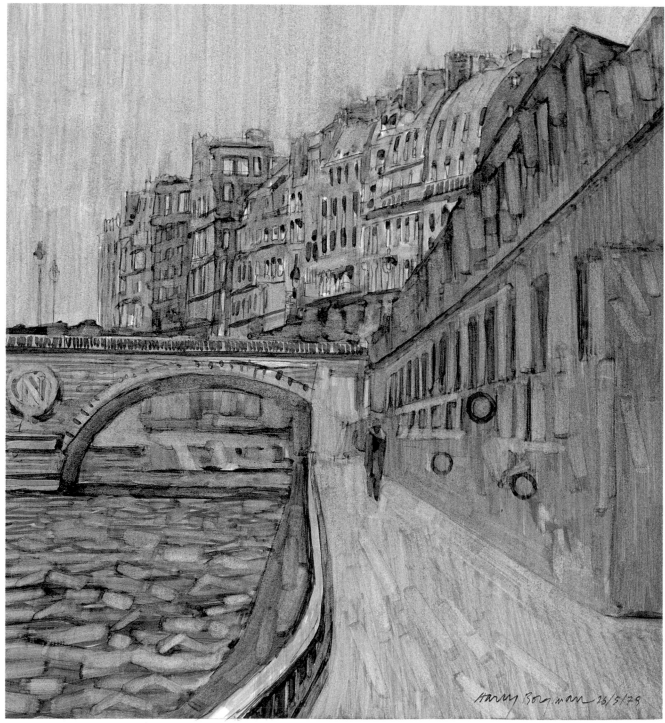

Along the Seine, 11⅝″ × 12½″ (29.5 × 31.8 cm)

Watercolor on Watercolor Paper, Portrait

This quick figure study is done on a watercolor block, a pad made up of many sheets of watercolor paper. The colors are painted in boldly without overworking, something you must be very careful to avoid when using watercolor. The flowers and other details are simply indicated with bold strokes. Watercolor can be a very difficult medium and you must plan what you are going to paint before you put it down. It is not easy to make major changes later.

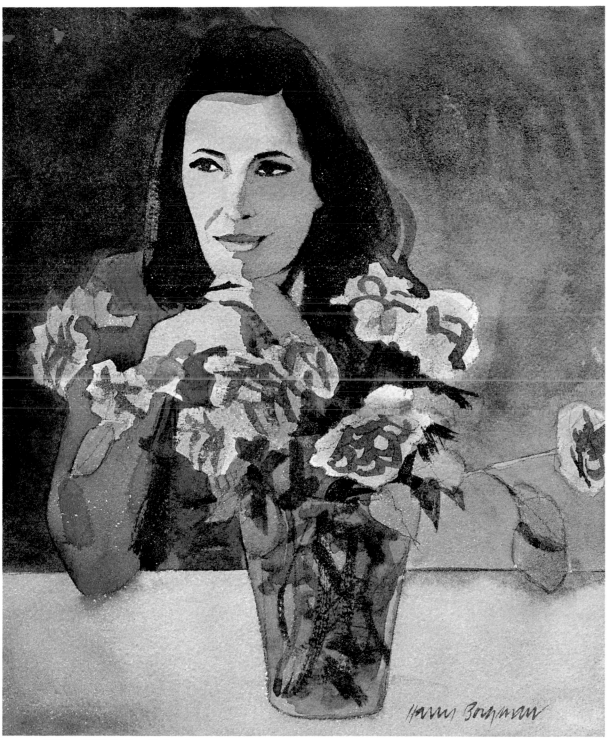

Jeanne, 10½″ × 12¾″ (26.7 × 32.4 cm)

Watercolor on Hot-Pressed Illustration Board

For this watercolor I use a very different type of surface. It is much harder and smoother than the usual watercolor paper, but still works well with the medium. While Demonstration 13 was done rather realistically, this one is rendered in a much more stylized, decorative manner. Even though it is painted from life, I ignore perspective and choose to treat the general design of the painting in a two-dimensional way. The shadows are also used as a design element and are not painted as they appear. This kind of painting is a good exercise to experiment with color and design. Doing design studies can extend your vision and will create many new picture possibilities for you.

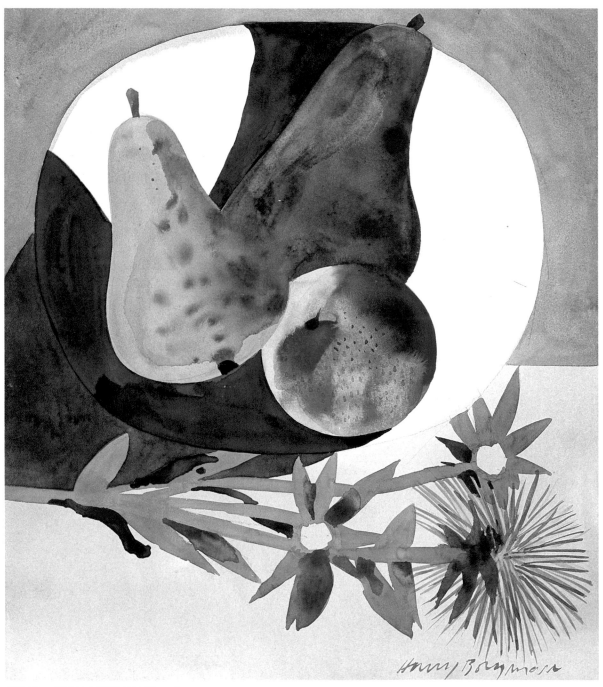

Still Life, 9½″ × 11″ (24.2 × 28 cm)

Watercolor on Rough Watercolor Board

This type of painting is a natural for the watercolor medium. I start this painting by first doing a drawing on the board with an Eberhard Faber Design Art marker pen. The basic drawing could also be done with a graphite pencil or even in watercolor. While this painting is not done on-the-spot, it does have that quality of *being done "on location." I paint this using a photograph taken in London on a sunny day, but I thought it would be more interesting as a rainy scene. Even though I often work from photographs, I do a lot of painting on location, since it is good practice and you also have some interesting mementos of your travels.*

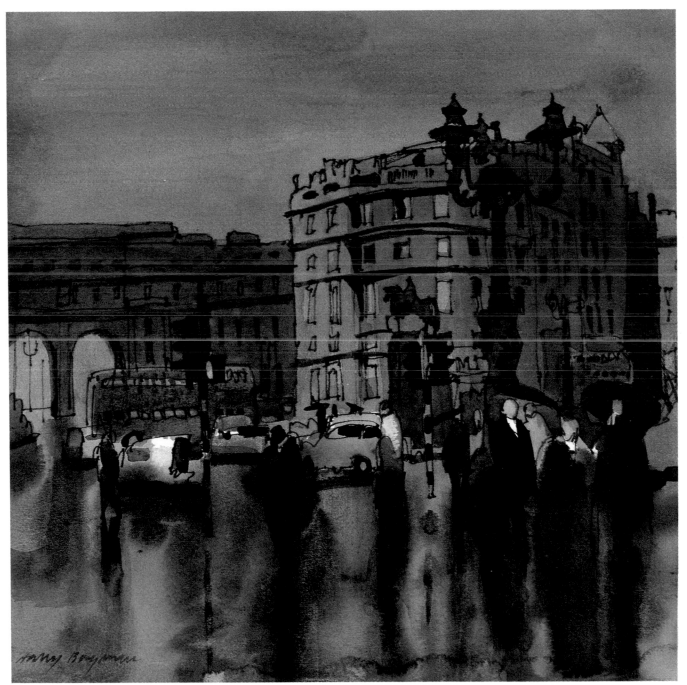

London Rain, 12⅝″ × 12½″ (32.1 × 31.8 cm)

Designers Colors on Rough Watercolor Board

In this example I use designers colors in much the same manner as watercolor. I start out by painting completely in washes of color, and as I progress, certain areas such as the sky and background mountain are painted using opaque paint. Designers colors are an excellent medium and you can work with them in many different ways.

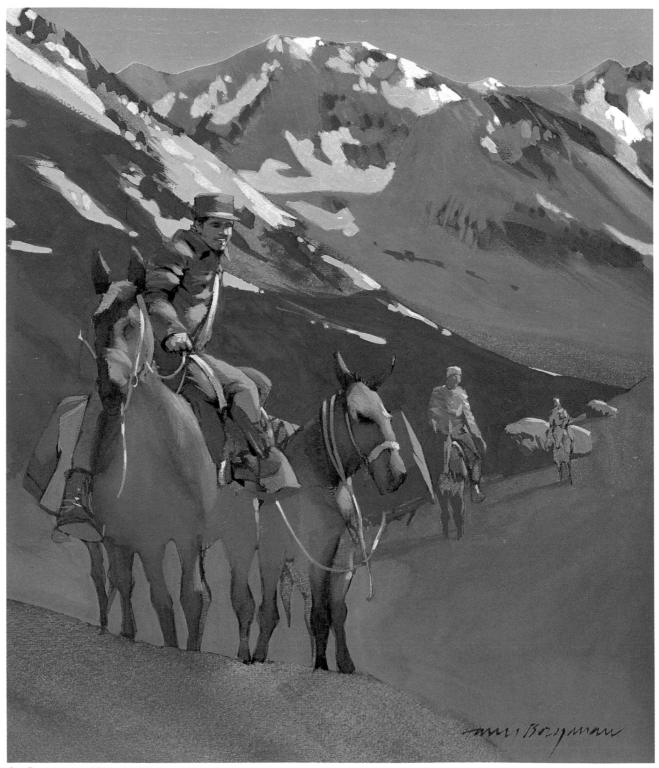

On Aconcaqua. 12″ × 14″ (30.5 × 35.6 cm)

DEMONSTRATION 17
Designers Colors on Illustration Board

This illustration was first started by doing a painted comprehensive sketch, which had to be presented to the client. For this I do an accurate graphite pencil drawing, and make photostats of the printed size. I paint the colors directly on the photostat. In this way, I could quickly paint two or three small comps and select the one I felt worked the best. The client had a few changes for me to incorporate in the final art.

The final illustration (below). Doing a comp sketch does help to determine what the finished illustration will look like. This painting is done on a hot-pressed illustration board, using a combination of washes and opaque paint.

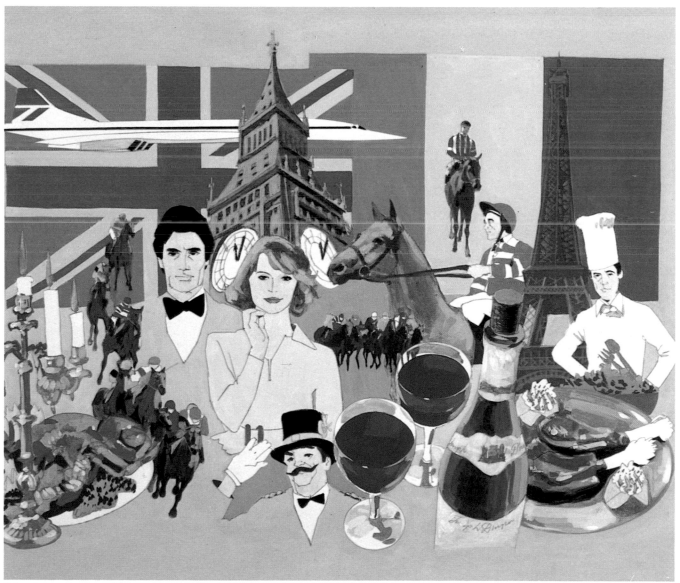

Advertising Brochure Illustration, 14½″ × 10″ (36.8 × 25.4 cm)

Acrylic Paint on Canvas, Impressionist Technique

Acrylic paint is a fascinating medium that can be used many different ways on various surfaces. You can paint in a manner similar to oil, or even paint wet and loose as with watercolor. This scene was painted after having visited the Normandy beaches in northern France. It is painted in an impressionistic manner, attempting to capture the feeling of the day that I was there. This picture was painted with a limited color palette.

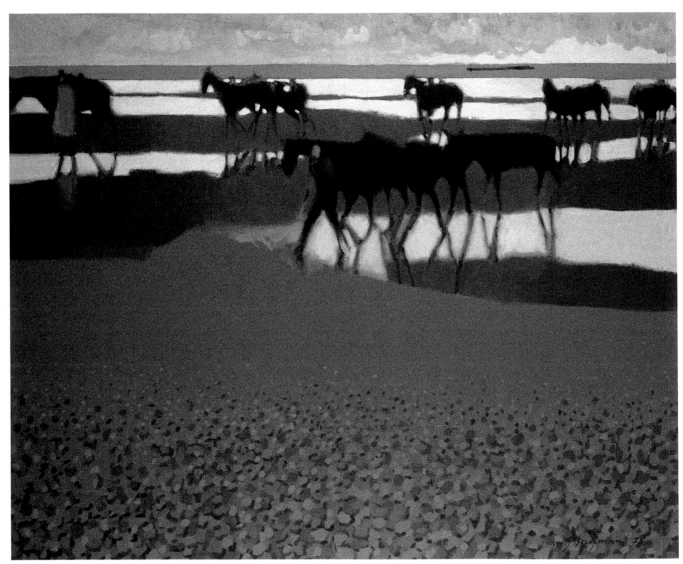

Omaha Beach, Normandy. 36″ × 30″ (91.4 × 76.2 cm)

Acrylic Paint on Canvas

Here is an example of the type of non-objective paintings I enjoy doing. It is basically a study in color and design. Usually, I have no particular idea when starting a painting like this, and I often begin by simply pouring or brushing paint onto the canvas. These shapes often suggest a design that I use as a basis for the finished painting.

Prospect, 36″ × 30″ (91.4 × 76.2 cm)

Acrylic Illustration on Canvas

This illustration for the French aerospace program is done on canvas with acrylic. I start the painting by doing my basic drawing directly on the canvas using a brush and black paint. There was, of course, a lot of preliminary work such as sketches and layouts, which are shown in Demonstration 20, page 106.

Aerospatiale/Nordsat Illustration, 15″ × 18″ (38 × 46 cm)

Acrylic on Canvas, Figure Study

This figure study is painted in very much the same manner as oil. I start this painting by drawing the figure directly onto the canvas with a bristle brush and black acrylic paint. In this painting, as in many of the others, I use a very limited palette. Even though it is a realistic rendition, the painting is still a study in color and design, as is some of my non-objective work.

Reclining Figure with Shoes, 20″ ×20″ (50.8 × 50.8 cm)

Acrylic on Canvas

This market scene is painted from color slides taken while on a vacation. Although this paint- *ing is fairly realistic, it has a very strong design quality.*

Makola Market, Ghana, *24" × 18" (61 × 45.7 cm)*

Acrylic on Illustration Board

Here is an abstraction of the Makola market, painted with both transparent and opaque washes of acrylic paint. This painting won sec- *ond prize in a Scarab Club Watercolor Show in Michigan.*

Makola Market, 19½″ × 19½″ (49.5 × 49.5 cm)

Acrylic on Canvas

This scene is painted from several photographs taken at a Michigan rodeo. To really capture the *action, I keep the painting rather loose and use multiple views of the rider roping the calf.*

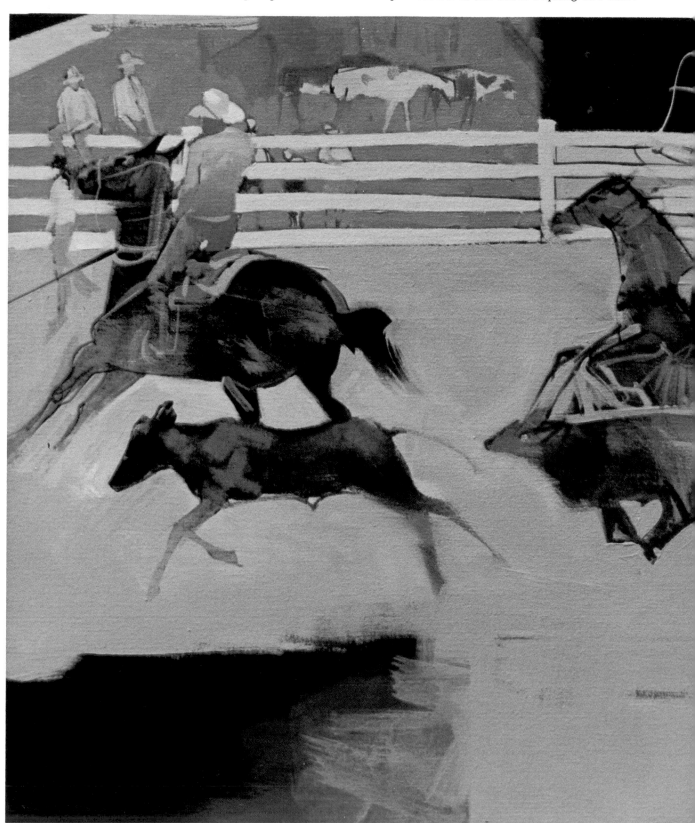

Hillsdale Rodeo, 34″ × 24″ (86.3 × 61 cm)

Acrylic on Canvas

This abstract painting is based on a map of one of the levels in the ancient city of Troy. It is painted with very thin washes of color, but the background around the city shape is painted with opaque paint.

Troy, 36″ × 36″ (91.4 × 91.4 cm)

Designers Colors and Colored Pencils

Mixing mediums can be very interesting, but it does not have to be limited to paint. Using colored pencils with paint can be a fascinating combination that offers great possibilities for experimentation. In this painting, I start out by drawing the rider, horse, and foreground figures; then I add designers colors washes over the whole picture. Over this I work with more of the colored pencils. The white square, highlighting the rider, is masked off with Scotch Magic tape. I use Eagle Prismacolor pencils, but there are other fine brands available. There are colored pencils that will dissolve when water is washed over the pencil tone.

Hillsdale Rodeo, 18⅜″ × 15⅜″ (46.7 × 39.1 cm)

Ink Line and Designers Colors

This technique is often used for advertising illustrations because it reproduces very well. It is a way to convert certain ink line drawings to full-color illustrations. The basic art is really a black-and-white ink line drawing from which a film positive is made. The color is then painted on illustration board, using the film positive as a guide. Refer to Demonstration 23, page 120 for the complete steps.

French Spad in Action, 18″ × 12″ (45.7 × 30.5 cm)

Markers, Paint, and Dyes on Illustration Board

For this illustration I used marking pens, ink, designers colors, dyes, and even acrylics. Most mediums will mix quite well and just about any combination will work. The basic drawing for this illustration is done using a Pentel Sign pen. The ink from these pens will dissolve when you wash over with paint, so you must be careful.

Travel Montage, 15½″ × 10⅜″ (39.4 × 26.3 cm)

Ink and Watercolor on Aquarius Paper

This combination ink and watercolor painting is done on a very interesting fiberglass paper by Strathmore. The paper, Aquarius, will not wrinkle or buckle as most watercolor papers do when water-saturated. I like to use this paper for on-the-spot sketching. This painting is done using an abstract, decorative approach, but it nevertheless gives a very good impression of the scene as it was.

Cairo from the West Bank of the Nile, 10″ × 9″ (25.4 × 22.9 cm)

Ink and Watercolor

This is another painting from one of my sketch-books, and is done on Strathmore Alexis paper. For my basic drawing I use a technical pen with a brown ink cartridge. When traveling I often carry a compact Winsor and Newton watercolor box, which holds its own water supply. This makes it quite easy to paint on-the-spot.

Khartoum, Sudan, 7" × 9½" (17.8 × 24.1 cm)

Watercolor and Markers

The basic drawing is done with a Pentel Sign pen. You can see how the ink dissolves when I wash the color over. This is an excellent technique for outdoor sketching.

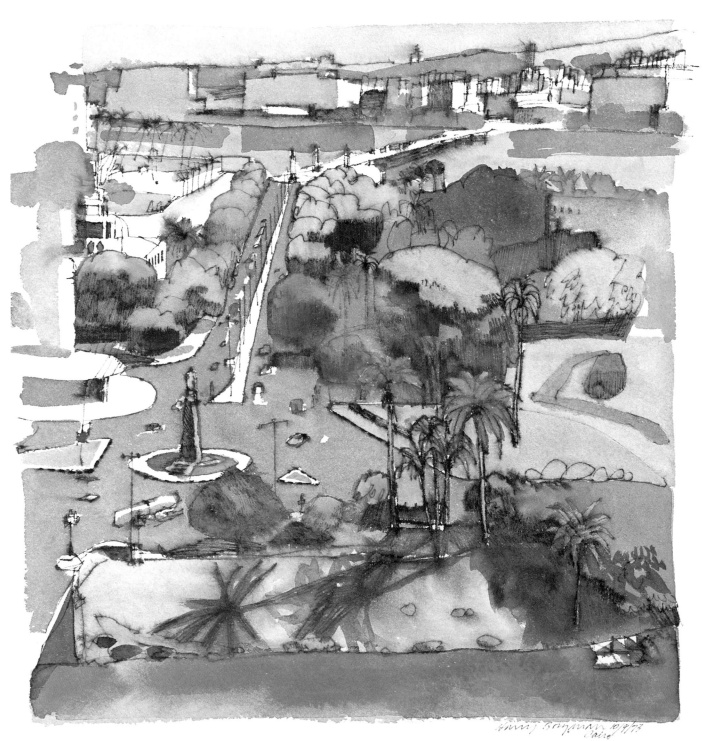

Cairo, 11″ × 12″ (27.9 × 30.5 cm)

Pencil, Designers Colors, and Acrylic on Illustration Board

My basic drawing is done with a graphite pencil on a very smooth, hot-pressed illustration board. Then, washes of color and opaque paint are applied over this. I use this technique for much of the illustration work I do.

Mexican Travel Brochure Illustration, 11¾″ × 13″ (29.9 × 33 cm)

Designers Colors, Acrylic, and Opaque Color

This example was handled in much the same manner as the previous one, page 155, but this is a more decorative design approach. I use washes of designers colors and acrylics, as well as opaque color.

Hawaii Travel Brochure Illustration, 12⅛″ × 6″ (30.8 × 15.2 cm)

Acrylic Paint with Acrylic Medium

My basic drawing here is done with a soft graphite pencil on a very smooth illustration board. Then I photostat this drawing and mount the photostat on mount board. I paint over the photostat using acrylic paint mixed with acrylic *medium. This gives a transparent glazed effect, which looks like the aircraft are in the clouds. If my painting had not worked out, I could have gotten another photostat of the original drawing and started over.*

Air Battle, 16″ × 12″ (40.7 × 30.5 cm)

Designers Colors and Acrylic

These two paperback covers are illustrations for Ace Books, Inc. On both covers, I use designers colors and acrylics in combination. These two paintings are almost totally done with washes of color on hot-pressed illustration board.

Designers Colors and Acrylic

A paperback cover for Pinnacle Books–from a group I did for the Dracula series. Again, this was a combination of designers colors and acrylic used in a thick, opaque manner.

Another cover in designers colors and acrylic for Ace Books. I also used an airbrush to paint in the floating objects. On this illustration, I needed a quick model, so I posed and set my Polaroid camera on the self timer.

Paperback Cover Illustrations, 12″ × 21″ (30.5 × 53.3 cm)

Ink, Dyes, and Designers Colors

For this assignment I did a comprehensive sketch in Magic Markers and a technical drawing pen. The client liked the feeling of the sketch so well that he asked me to duplicate the exact look in the finished art. I used a technical pen for *the basic line drawing. The color was added with washes of dyes and transparent designers colors. It was painted on Strathmore regular surface bristol board.*

Foxboro Brochure, 15½" × 12¾" (39.4 × 32.4 cm)

Part 4
Additional Hints

Most artists have their own methods of working, yet they all share similar problems. Surely it is through trial and error that artists learn, however, there are certain helpful hints I can pass along to you. Today, there are many sophisticated techniques and products that can simplify difficult problems. The question is: how can the artist utilize these means to their fullest advantage?

In this final section of the book, I first discuss drawing aids—time-saving methods and devices that most professionals use in their work: fixatives, masking tape, X-acto knives, triangles and French curves, pens, rulers, and opaque projectors. Then I explain how to correct drawings and illustrations in any medium: acrylic, ink line or wash, gouache or watercolor. Next, I show you how to get ideas. Finally, I discuss a problem that all artists share: how to develop yourself as an artist.

Drawing Aids

Today, there are a great many aids that can simplify difficult problems and also save a great deal of time. While most of these things are not a necessity, they can certainly come in handy. Using a workable fixative spray over pencil and charcoal drawings will prevent them from being smudged or ruined. Masking tape or pushpins help to hold your paper or illustration board in place while working. A standard X-acto knife has many uses: cutting paper and board and even sharpening your pencils. Triangles and French curves can help a great deal when drawing certain things. I find them most helpful when ruling curved or straight lines with a technical pen. Guides are also available that really simplify the job of drawing accurate ovals and circles. An item that also might prove useful is a combination pencil and ink compass for drawing circles. Another good thing to own is a ruling pen or a technical pen. A good steel ruler can help when cutting paper, illustration board and even mats.

As I mentioned before, most of these things are not really necessary, but you may find a few items that you will want to buy. Do not overburden yourself with a lot of unnecessary gadgets; it can also get quite expensive. To familiarize yourself with available tools and materials, pick up or send for a catalog from a large art store.

The Opaque Projector

An opaque projector is useful for projecting drawings or photographs onto illustration board. This can be a real time saver, since it eliminates the step of tracing your tissue drawing with a tracing sheet. A projector also enables you to easily enlarge or reduce your sketch or drawing. This is done by simply moving the projector back and forth and focusing the lens until the desired size is achieved. My projector is mounted on a platform with castors for easy movement. I use the Beseler Vu-Lyte 11, which is equipped with a special reducing attachment. The reducing device was not standard, but was added by Lewis Artist Supply of Detroit, Michigan. A 35mm color slide projector can be used to project color slides directly onto illustration board in the same manner.

Correcting Drawings and Illustrations

There are many ways to correct mistakes or ruined areas on drawings and paintings. With acrylic paintings or other opaque paint, you can simply repaint the area that is not right. On ink line or wash illustrations, correcting can be rather difficult. In this case, the least desirable method would be to paint out the mistake with white paint and redo the area. This method can work, but the results look rather unprofessional. The best method to correct ink line drawings or wash paintings is to use an electric eraser. You simply grind the board surface clean, then paint or draw over the clean area. Eraser plugs are available in two grades, one for delicate work such as wash drawings, and the other for tougher jobs such as ink line drawings. A metal erasing shield helps to limit the area being erased. Another alternative to using white paint for corrections is the fiberglass eraser. This eraser is excellent for correcting ink line drawings. However, I should warn you that your work must only be done on the highest quality illustration boards, since the cheaper grades will not hold up well under erasure.

Other methods can also be utilized for correcting paintings. Often, when I want to make some changes on a gouache or watercolor painting, I wet the area with clear water and blot up the paint with a blotter. When most of the paint has been removed and the area is thoroughly dry, I can repaint it easily.

Another suggestion that you might try when correcting artwork is to use a treated acetate. This special clear acetate is treated so you can paint on it. You lay the acetate over your painting, and paint the area in question—until you get the effect you want. Then, remove the acetate and repaint the area on your illustration, using the painted acetate as a guide.

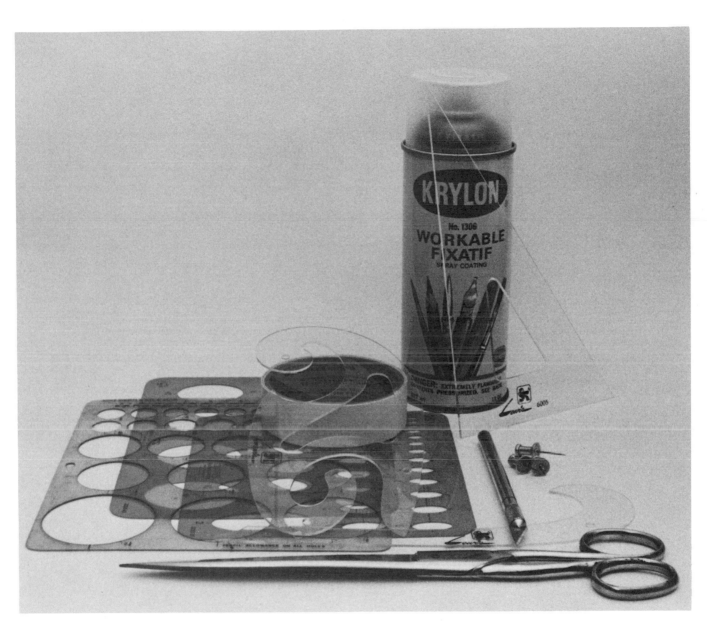

Here are a few handy aids for the artist: workable fixative for spraying pencil and charcoal drawings, scissors, masking tape, push pins, an X-acto knife, triangle, circle/oval guides, and French curves.

Curves are especially useful for ruling ink lines when drawing mechanical subjects. Here I am using a technical pen with a curve on the drawing from Demonstration 24.

On this same drawing (above right), I use oval guides to draw and ink in the wheels, again using the technical pen for the rendering.

(Left) Here are a few other items that I find quite useful. Graphite sticks can be used for drawing and also for making a tracing sheet for transferring drawings to illustration board. Scotch Magic tape is excellent for masking out areas or edges of illustrations, since it will not buckle or lift when wet as most other tapes do. I use pliers to open stubborn paint caps and also for removing the inner core of the Magic Marker to paint a large color area.

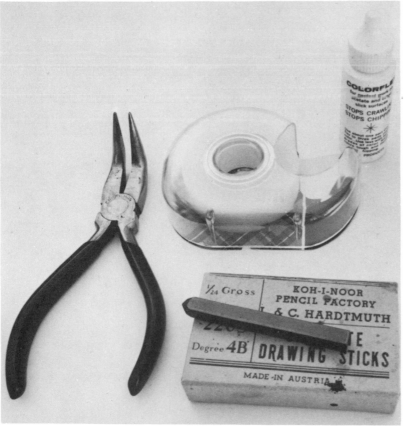

A tracing sheet is required when tissue drawings are to be transferred to illustration board. To make a tracing sheet, rub a 4B or 6B graphite stick on a sheet of thin layout paper or tracing paper, covering the entire surface thoroughly. Then, dampen a piece of cotton with Bestine, a thinner for rubber cement, and rub this over the graphite surface.

Keep rubbing the dampened cotton over the whole sheet until the graphite surface has dissolved into a nice, even black tone. Now, take a piece of dry cotton and briskly rub this over the whole sheet to remove any excess graphite. The tracing sheet is now ready to use. Tape your tissue drawing at the top, to your illustration board. Place the tracing sheet, graphite side down, between the board and the drawing. Then, using a stylus or a hard grade pencil such as a 4H, trace down your drawing. You should occasionally lift the sheets to check that you have not missed tracing anything.

The only way to paint a large flat marker tone is to use the inner core of the Magic Marker. The core should be removed with a needle-nosed plier. The core is also held with the plier when using it to paint large color areas. This method assures a smooth, even tone.

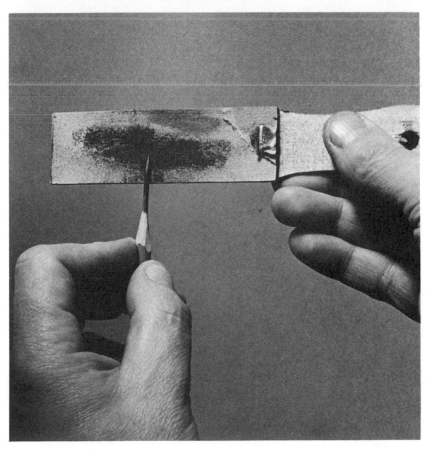

An indispensable item is a sanding block. You can shape pencil leads to a very fine point after first sharpening them with an X-acto knife.

This is the Beseler Vu-Lyte 11 with the special reducing attachment. This device enables the lens to be used in an extended foreward position, reducing the projected image from actual size.

The Beseler can project a drawing or photograph measuring up to 10″ × 10″ (25.4 × 25.4 cm). Of course, larger pieces can be projected in sections. The item to be projected is inserted into the carrier as shown.

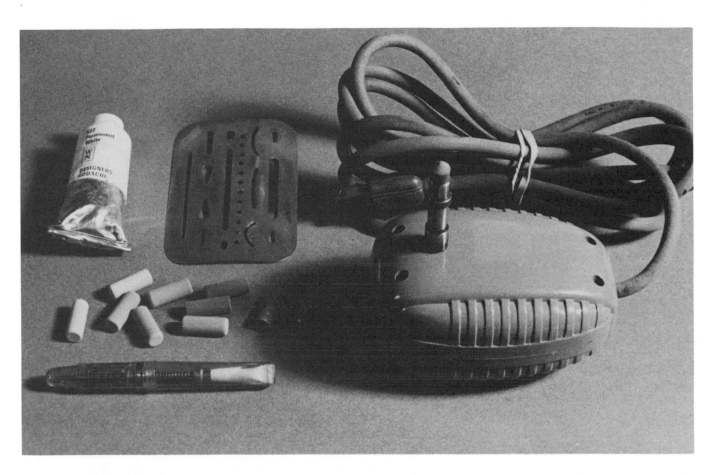

Here are some items that can be used for correcting drawings or paintings. White paint works well but does not look as professional as when a fiberglass or electric eraser is used. The electric eraser works best, and eraser plugs are available in two grades. A metal erasing shield is helpful when using either eraser.

This is the electric eraser in action. It is the fastest, cleanest method you can use to correct ink line, wash drawings, or illustrations. The shield helps confine the erasing to specific areas.

Getting Ideas

One of the best idea sources for painting is photographs. You can base paintings on your own photographs, or even get ideas from pictures found in magazines or books. Some good sources for painting ideas are nature and travel publications, such as *National Geographic* and *Town and Country*. I prefer to use my own photographs as painting idea sources and am constantly taking pictures for future use. Over the years on trips and vacations I have accumulated quite a collection of material.

You really don't need expensive camera equipment for shooting reference material, but a camera with interchangeable lenses offers obvious advantages over a fixed lens camera. I use a Nikon FTn reflex camera for most of my photography and include a 135mm telephoto and a 24mm wide-angle lens as part of my gear. Your choice of camera should be according to your own preference and what your wallet can handle. Do not overlook the used camera buys, which will allow you to buy more equipment at a lower cost.

In my business of advertising art, I am frequently up against severe time deadlines. Often, this time factor does not allow me to have film developed or prints made and I must shoot my reference material with a Polaroid camera. In fact, most of the time, when doing advertising work, I rely on my Polaroid 180 camera.

Another good source for painting ideas can be sketches or doodles. Doodles should be kept in a file and your sketches, if done in a sketchbook, kept on a bookshelf for future reference.

Sometimes if I have no specific idea and want to start a painting, I simply start painting shapes and colors on the canvas or illustration board, often this suggests something that develops into a painting. Demonstration 19 is an example of this method. For me, it is important just to get something down on board or canvas and then go on from there.

Seeing other artist's work can be very stimulating and inspiring, so I spend a good deal of time in art museums and galleries.

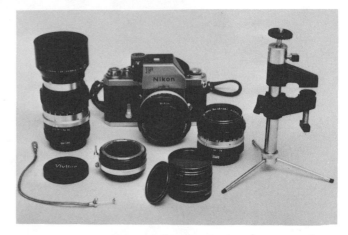

A fine basic camera and a few extra lenses can be very useful to an artist. Here is my trusty Nikon FTn with 50mm lens. The telephoto is a 135mm and I utilize a 2× teleconverter to turn it into a 270mm. The wide angle lens I prefer is the 24mm. Several color filters, as well as a closeup lens, are useful. The small table tripod is good for time exposures; I also have a larger one. The cable release is necessary when shooting time or long exposures.

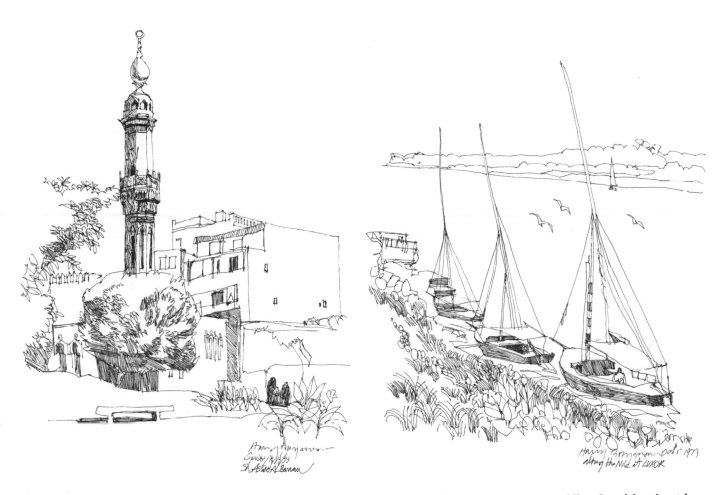

Here are a couple of quick sketches done while vacationing in Egypt. They are quite loose but still afford the possibility of further development into paintings. When traveling, try to fill a sketchbook with simple quick diagrams or sketches.

(Left) I shoot quite a few pictures when traveling around the city and generally always carry my camera. A lab develops the film, and I request a same size contact sheet that shows me what is on the film. I file this contact sheet for future reference and can order 8" × 10" (20.3 × 25.4 cm) prints at a later date.

It probably seems strange, but doodles can be the basis for drawings or paintings. I have done paintings based on the two doodles on the left. The examples on the right were done while talking on the telephone. I have not developed these into paintings, but they do offer possibilities.

I often use a Polaroid camera and enjoy experimenting with it. Sometimes, double exposures are interesting enough to base paintings on. Overexposing and underexposing can yield very interesting results. Also, try experimenting with Polaroid color film and different filters.

Developing Yourself as an Artist

When I search for a key word or phrase to tell you, I think of *see* or *learn how to see*. Drawing and painting are really "seeing," and you can train yourself to "see." You can learn to recognize scenes or objects that will make interesting pictures. For this reason it is a good idea to do a lot of outdoor sketching.

I think the attributes an artist should have are awareness, knowledge, and discipline. A good all-round education and being interested in many things can help you. If you are still a student you should prepare yourself now, since it will be very important for your future. An art education should also be one of your goals, and studying in a good art school with professional artists and instructors will help greatly. Another way you can develop as an artist is to study other artists' work, which means visiting museums, galleries, and art exhibitions or shows. A wealth of knowledge can be learned by this kind of "seeing."

A beginning artist should always practice and become familiar with various mediums and techniques. Actually, you cannot practice enough. Even established artists are constantly working and experimenting with new mediums and techniques. An artist's whole life should be one of constant development and growth, and the various mediums certainly offer an endless world of exploration and excitement.

In addition to following art shows and exhibitions, read as much about art as you can in art magazines and books. Here you will find a vast storehouse of information just waiting to be tapped.

Also, associate with other artists so that you can discuss problems and become exposed to other points of view. If you admire the work of an artist or illustrator, start a file on the artist's work and collect prints for further study.

Earlier, I mentioned discipline, which might be the most important attribute an artist can have. Much of what an artist does, painting and drawing, is self motivated—no one will tell you to do a painting, no one is forcing you to work. Discipline requires will and effort on your part. If any problem seems difficult or even impossible, you must have the determination to work and overcome the situation. Without strong discipline it is doubtful that a person can really develop as an artist.

Before you paint, you should have a pretty good knowledge and background in composition and basic drawing. I would suggest taking a few basic and life drawing classes. Even if you can only take one class in the evening or on Saturday, it will help you immensely. After a short time, you will be better prepared to start working with the various painting mediums.

It is really quite important to practice with all the mediums and tools, so that you will really know their advantages and limitations. Do not avoid a medium that at first seems difficult. You can learn a great deal from mistakes and eventually will not repeat them. Many artists feel more comfortable with a certain medium. To find out if you prefer one medium over another, you must explore them all.

Many career possibilities are available to artists. The field of advertising art can be quite lucrative and is full of opportunities, especially in the larger cities such as New York, Chicago, Los Angeles, Toronto, Detroit, London, Paris, and Frankfort. Within the business there are many areas of work that an artist can pursue, but the competition can be quite severe. Illus-

trators, layout artists, designers, TV storyboard renderers, retouchers, and art directors are employed by art studios and advertising agencies. In addition, most newspapers, magazines, printing firms, retail stores, and small or large corporations employ artists for a variety of jobs. Many of the artists produce company-related material such as brochures, magazines, newspapers, and annual reports. You can even work as a freelance artist, if you are established in your field and in demand.

A good suggestion for a beginner would be to visit a large art studio or advertising agency and ask to talk to someone about the business. Most advertising people and artists are very helpful and will be happy to show you their work and discuss what they do. Incidentally, one of the best ways to get started in the advertising business is to start right at the bottom, as an apprentice in an advertising agency or art studio. In this way you get a first-hand look at the business and gain invaluable knowledge that would otherwise be unavailable to you. However, apprentice jobs are not that easy to obtain since many other young artists are after these positions. One way to have an edge on the competition is to put together a good, strong portfolio of drawings and paintings to present when applying for a job. Art studios and some advertising agencies prefer to give these jobs to young artists who show a lot of promise. Only your best work should go into your portfolio, preferably a variety of mediums.

The fine art field is a difficult one to get into, and there are fewer opportunities. An artist's work must be unique and good enough to interest a gallery owner. If this field interests you, try to enter as many shows and art competitions as possible. Winning a couple of prizes can certainly help gain the attention of a gallery owner, who in turn might exhibit your work and represent you.

It is not very easy to be a successful artist, but it certainly can be worth the effort. The rewards, both monetary and personal, can be great. How far you go is up to you, but there is always room at the top for fresh new talent.

Index

Numbers in italics indicate finished paintings.

Edited by Donna Wilkinson
Designed by Jay Anning
Graphic Production by Hector Campbell
Set in 11 Point Memphis Light